2001

IN THE POWER OF PAINTING

IN THE POWER

A Selection from the Daros Collection
Eine Auswahl aus der Daros Collection

OF PAINTING

Andy Warhol

Sigmar Polke

Gerhard Richter

Cy Twombly

Brice Marden

Ross Bleckner

Alesco AG Zürich
Scalo Zürich · Berlin · New York
2000

Vorwort Foreword

"... ich scheue mich, das zu benennen, was Malerei uns gibt. Ich weiss nur, dass sie nützlich und wichtig ist, ...dass Malerei also etwas ganz und gar Lebensnotwendiges ist."

Gerhard Richter[1]

Das Statement von Gerhard Richter deutet an, wie schwierig es in der zweiten Hälfte des 20. Jahrhunderts ist, Bilder zu malen. Gleichzeitig zeugt es vom unerschütterlichen Glauben an die Kraft der Malerei. Eine Sammlung internationaler Gegenwartskunst der letzten fünfzig Jahre, wie es die Daros Collection ist, kommt um die Frage, was die Malerei nach dem Abstrakten Expressionismus zu leisten vermag, nicht herum. Wir stellen uns der Frage und möchten zu deren Diskussion beitragen. Aus dem Fundus der Daros Collection haben wir sechs internationale Künstler verschiedener Generationen ausgewählt, deren Haltung als Maler wir als ernsthaft, konsequent, reflektiert und einflussreich beurteilen. Das Projekt *In the Power of Painting* unterscheidet sich in verschiedenen Belangen von den Ausstellungen zum Thema der Malerei der letzten Jahrzehnte, wie sie etwa 1981 in London sowie in den 90er Jahren in zahlreichen Museen Europas zu sehen waren [2] Diese zeig-

"... I shy away from naming what painting gives us. I only know that it is useful and important, ... that painting is in fact essential to life."

Gerhard Richter[1]

Gerhard Richter's statement indicates how difficult it has been to paint pictures in the second half of the 20th century. It also testifies to his unshakable faith in the power of painting. A collection of international contemporary art over the past fifty years, such as the Daros Collection, must inevitably face the question of what painting after Abstract Expressionism has been able to achieve. We accept the challenge and wish to contribute to the debate. From the holdings of the Daros Collection we have selected six international artists of different generations, whose attitude as painters we consider serious, consistent, reflected, and influential. The project, In the Power of Painting, *differs in various ways from other exhibitions on painting organized, for instance, in London in 1981 or by numerous European museums throughout the nineties.[2] For the most part, these exhi-*

ten meistens mittels eines Schnittes durch die Produktion der letzten drei bis vier Jahre einer grossen Zahl von Künstlerinnen und Künstlern aktuelle Trends und auch die Vielfalt der Malerei der Gegenwart auf. Uns geht es nicht um eine enzyklopädische Übersicht, sondern darum, über eine längere historische Periode hinweg einzelne Positionen vorzustellen und die individuellen Wege, die die Künstler gegangen sind, nachvollziehbar zu machen. Die hier gezeigten Gemälde datieren von 1949 bis 1998. Sie umspannen ein bewegtes halbes Jahrhundert Kunstgeschichte und reagieren durch ihre Haltungen auf die unterschiedlichsten kulturgeschichtlichen Diskurse dieser Epoche. Dabei sind Gemeinsamkeiten auszumachen, beispielsweise die zunehmende Bedeutung der Bildwelt des Alltags, die generelle Frage nach Vermögen der Malerei, die reale Welt abzubilden, oder der bewusste Einsatz von Material und Maltechnik. Es gibt aber auch Unterschiede, etwa geographischen Ursprungs, die deutlich werden, wenn wir den amerikanischen Popkünstler Andy Warhol den beiden Deutschen Polke und Richter gegenüberstellen.

In the Power of Painting ergänzt in idealer Weise die erste Publikation mit Werken aus der Daros Collection, *Abstraction, Gesture, Ecriture*.[3] Diese umfasst Künstlerinnen und Künstler, welche sich direkt mit dem Erbe des Abstrakten Expressionismus auseinandersetzen. Drei dieser Maler, Twombly, Warhol und Marden, sind auch hier wieder vertreten, nun aber grösstenteils mit anderen Werken, die deren künstleri-

bitions showed current trends and demonstrated the diversity of contemporary painting by presenting a cross section of work from the preceding three or four years by a great number of artists. Our objective is not to present an encyclopedic survey but rather to introduce specific positions and trace the individual paths pursued by the artists within the context of a historical period ranging over the past decades, from 1949 to 1998. They cover half a century of turbulent art history and their attitudes embody reactions to the most varied discourses of this epoch. Their work shares common features such as the increasing significance of popular imagery, the general concern with painting's ability to depict the real world, or the conscious use of materials and painting techniques. But differences also become apparent, for instance, of geographical origin, when we juxtapose American artist Andy Warhol with his two German colleagues, Polke and Richter.

In the Power of Painting *ideally complements the first publication of works from the Daros Collection,* Abstraction, Gesture, Ecriture.[3] *The latter comprises artists directly involved with the heritage of Abstract Expressionism. Three of these painters, Twombly, Warhol, and Marden, are also represented in the present project, but largely with a different selection of works that traces their artistic careers*

sche Karrieren von den Anfängen bis zu den ersten Höhepunkten nachzeichnen. Einige kürzliche Neuerwerbungen von wichtigen Gemälden von Twombly, Marden und Richter kommen unserer Sammlung und somit auch dieser Publikation zugute. Sie exemplifizieren gleichzeitig das Prinzip von "collecting in depth", das wir mit der Daros Collection verfolgen, und bestärken uns, diese Politik fortzusetzen.

Anlass zu dieser Publikation ist eine Ausstellung, die wir gemeinsam mit dem Moderna Museet in Stockholm vorbereitet haben, und die dort im Februar und März 2000 gezeigt wird. Im Herbst werden wir die Bilder dann in den sammlungseigenen neuen Räumen im Zürcher Löwenbräu-Areal präsentieren. Dabei wird es sich trotz der mehrheitlich identischen Exponate um zwei verschiedene Ausstellungen handeln, denn der architektonische Kontext ist ein anderer: in Stockholm die Galerien im Untergeschoss des Neubaus von Rafael Moneo von 1998, in Zürich eine mittels minimaler Eingriffe für Ausstellungszwecke umgebaute ehemalige Industriearchitektur. Die Ausstellung wird auch in zwei ganz verschiedene kunsthistorische Umgebungen gesetzt: In Stockholm in ein Museum mit einer traditionsreichen Sammlung und einem Ausstellungsprogramm, das sich gegenwärtig vorwiegend auf Medien abseits der Malerei konzentriert, in Zürich in einen Gebäudekomplex, der dank der Kunsthalle, dem Migros Museum und zahlreichen kommerziellen Galerien den ganz aktuellen Trends der Gegenwartskunst nachspürt.

from their beginnings to the first highlights. A few recent acquisitions of important paintings by Twombly, Marden, and Richter enhance our collection and, hence, this publication as well. Moreover, they exemplify the principle of "collecting in depth" and strengthen our resolve to pursue this characteristic policy of the Daros Collection.

This publication has been prepared on the occasion of an exhibition, organized in cooperation with the Moderna Museet in Stockholm, where it will be on view in February and March 2000. In the following autumn, we will present the paintings in our own new space at the Löwenbräu complex in Zurich. Although the same works, by and large, will be on view in both cases, the two exhibitions are quite distinct due to their architectural context: in Stockholm, the lower level galleries in Rafael Moneo's new building of 1998; in Zurich, former industrial premises minimally refurbished for exhibition purposes. Two entirely different art historical surroundings are involved as well: in Stockholm, a museum with a collection rich in tradition and an exhibition program currently focusing mainly on media other than painting; in Zurich, a building complex devoted to the latest trends in contemporary art thanks to the inspiring efforts of the Kunsthalle, the Migros Museum, and several commercial galleries, housed therein.

Ich möchte mich bei David Elliott, dem Direktor des Moderna Museet, sowie bei Iris Müller-Westermann, Kuratorin, und ihrem Kollegen Sören Engblom für ihr Interesse und ihre substanzielle Mitarbeit am Projekt bedanken. Ganz besonders zu Dank verpflichtet bin ich meinem Team von Alesco, Peter Fischer, Kurator der Daros Collection, für die Initiative und Leitung des Projekts, Dieter Beer für die logistische Verantwortung, Sue Naef Gadient für die Mitarbeit bei der Konzeption und Produktion der Publikation, Hanspeter Marty für die konservatorische Betreuung und Beratung. Im weiteren danke ich Martin Hentschel und Michael Lüthy für ihre Textbeiträge, Catherine Schelbert für die englische Redaktion, Franziska Schott und Marco Schibig für die Gestaltung des Buches, Walter Keller für dessen Aufnahme in das Publikationsprogramm von Scalo sowie der Familie Müller von Lichtdruck Matthieu für die Druckqualität.

Die Ausstellung und das Buch wären nicht möglich ohne die Bereitschaft von Stephan Schmidheiny, dem Eigentümer der Daros Collection, seine Sammlung mit einer interessierten Öffentlichkeit zu teilen. Sie entspringt seiner Überzeugung, dass Kunst einen wesentlichen Beitrag zur Lebensqualität leistet.

Jacques Kaegi
Präsident des Verwaltungsrats
von Alesco AG

I wish to thank David Elliott, the director of the Moderna Museet, as well as Iris Müller-Westermann, curator, and her colleague Sören Engblom for their interest and their substantial collaboration on the project. I am especially grateful to my team at Alesco: Peter Fischer, curator of the Daros Collection, for his initiative and management of the project, Dieter Beer for the logistic organization, Sue Naef Gadient for her work on the concept and production of the publication, and Hanspeter Marty for his conservatorial expertise. Moreover, I wish to thank Martin Hentschel and Michael Lüthy for their contributions, Catherine Schelbert for the English editing, Franziska Schott and Marco Schibig for the design of the book, Walter Keller for including it in the Scalo program, and finally, the Müller family of Lichtdruck Matthieu for the quality of the printing.

The exhibition and the book would not have been possible without the willingness of Stephan Schmidheiny, the owner of the Daros Collection, to share his collection with an interested public. His commitment springs from the conviction that art substantially enriches the quality of life.

Jacques Kaegi
President of the board
of Alesco AG

Drei Stichworte zur Einführung

Introduction in Three Words

Peter Fischer

"LÖSUNGEN" 1. TEIL

Sigmar Polkes Bild aus seiner Serie *"Lösungen"* steht gleichsam als Motto am Anfang dieses Buches. Nach Lösungen verlangen mathematische Gleichungen, ebenso Rätsel und schwierige Aufgaben. Wir wissen, dass Polke Künstler ist und nicht Mathematiker, also nehmen wir an, er wolle uns etwas vermitteln, das über das rein Rechnerische hinausgeht, um so mehr, als er mit den arithmetischen Zeichen ein Instrumentarium benutzt, das wir als exakt, eindeutig und wahr kennengelernt haben und entsprechend gebrauchen. Polkes Auflösungen der Gleichungen widersprechen aber allen Regeln der Arithmetik, wie wir sie seit unserem ersten Schuljahr verinnerlicht haben. Der Widerspruch zwischen der autoritären Form und dem sich den Regeln widersetzenden Inhalt ist nicht nur spannungsgeladen und verunsichernd, sondern als Akt der Dekonstruktion auch ungeheuer befreiend. Polkes "Lösungen"

Sigmar Polke, *Untitled*, 1969
Öl auf Leinwand, 48 x 38 cm
Oil on canvas, 19 x 15 inches

"SOLUTIONS" PART 1

Sigmar Polke's picture from his series "Solutions" takes the place of a motto at the beginning of this book. Solutions are not only required for mathematical equations, but also for riddles and difficult tasks. We know that Polke is an artist and not a mathematician, and so we assume that he wants to communicate something that goes beyond mere calculation, especially since he has chosen to use a system of signs known to be exact, unambiguous, and true, and which we use as such. But Polke's equations blithely contradict the rules of arithmetic with which we have been inculcated since the first grade. The contradiction between authoritarian form and rule-breaking content is not only charged with tension and unsettling; as an act of deconstruction, it is also extremely liberating. Polke's "solutions" are metaphors

11

sind eine Metapher für Haltungen, die sich – wenn auch in unterschiedlicher Intensität – im letzten halben Jahrhundert in vielen Bereichen des menschlichen Zusammenlebens und der Kultur, insbesondere in der Kunst manifestieren. Sie sind programmatisch auch für die Haltungen der sechs für diesen Band ausgewählten Künstler, die sich, jeder in seinem eigenen kulturellen, geographischen und historischen Umfeld, innerhalb der Gattung der Malerei ihren Weg gebaut und für die Frage nach dem Sinn ihres Tuns ihre eigenen Antworten erarbeitet haben. Diese Künstler teilen die Erkenntnis des Verlusts der Selbstverständlichkeit und die Einsicht, dass einfache, eindeutige Antworten nicht mehr möglich sind. Dabei akzeptieren sie nicht nur, dass ihre "Lösungen" oft rätselhaft und mehrdeutig sind, diese Tatsache wird in vielen Fällen sogar zum Untersuchungsgegenstand und Thema ihrer Malerei.

for attitudes, manifested to varying degree in many sectors of human society and culture in the second half of the past century, but above all in art. They are also indicative of the attitudes of the six artists represented in this publication. They have each, in their respective cultural, geographical, and historical settings, carved a path for themselves in the genre of painting and elaborated their own distinctive answers to the meaning of their endeavors. These artists share the insight that it is no longer possible to give self-evident, simple, or clearcut answers. They not only accept the fact that their "solutions" are often enigmatic and ambiguous but frequently this fact even becomes the target of their investigations and the subject of their painting.

"DAS ENDE DER MALEREI"

Ins Klagelied vom Ende der Malerei werde ich hier nicht einstimmen. Es ist aber unumgänglich, sich dazu ein paar Gedanken zu machen, begleitet doch dieses Schlagwort die Geschichte der Kunst der letzten hundertfünfzig Jahre, genau gesagt seit der Erfindung der Fotografie, und es wird in den vergangenen fünfzig Jahren – in dieser Zeit entstanden die Gemälde unserer Künstler – geradezu inflationär gebraucht. Johannes Meinhardt hat sich ausführlich zu

"THE END OF PAINTING"

I will not join in the dirge on the end of painting. But a few thoughts on the subject are unavoidable since the slogan has accompanied the history of painting for the past 150 years, or more precisely since the invention of photography, and its use has escalated over the past fifty years, that is, during the time in which the paintings of our artists were produced. Johannes Meinhardt has discussed this issue in great detail,[4] but the definitive analysis of the end of painting is found in Yve-Alain Bois's

diesem Thema geäussert,[4] die grundlegende Analyse des Endes der Malerei leistete aber Yve-Alain Bois in seinem brillanten Essay "Painting: The Task of Mourning" von 1986,[5] auf den ich mich in den folgenden Ausführungen beziehe. Der Begriff vom Ende der Malerei schliesst die Fragen nach dem Beginn des Endes und nach den verbleibenden Möglichkeiten der Malerei ein und ist an eine Geschichtlichkeit gebunden, genau gesagt an die Geschichte, die man gemeinhin *Moderne* nennt. Es waren drei auslösende Faktoren, die die traditionelle Malerei bedrängten und die Entwicklung neuer Denkmodelle erforderten: Die Erfindung der Fotografie trat in Konkurrenz mit der Abbildungsfunktion der Malerei; die Industrialisierung, Mechanisierung und die neuen Reproduktionstechniken stellten das Handwerk in Frage; schliesslich schwappte die dem kapitalistischen System inhärente Fetischisierung von Waren und Gebrauchsgütern auf Kunstwerke über – zu Beginn des 20. Jahrhunderts entwickelte sich der heute noch gültige Kunstmarkt, der als geschlossenes System funktioniert und auf Prinzipien wie Seltenheit, Authentizität, Angebot und Nachfrage sowie Wertsteigerung beruht. Der Druck dieser drei Faktoren führte zum Konzept der Moderne, welche sich von äusserem Zwang befreien wollte und von der Annahme ausging, es gäbe eine innere Wahrheit, die aber verborgen sei, und diese gälte es freizulegen, indem man Schicht für Schicht abträgt, bis die reine Essenz zum Vorschein kommt.

brilliant essay "Painting: The Task of Mourning" of 1986,[5] to which I refer in the following remarks. The concept of the end of painting necessarily implies questions regarding the beginning of the end and what possibilities still remain for painting; it is also bound up with historicity, specifically with the history of what is commonly known as modernism. Three factors contributed to the predicament of painting and required the development of new models: the invention of photography competed with the representative function of painting; industrialization, mechanization, and new techniques of reproduction undermined handcraftsmanship; finally the fetishization of goods and commodities, inherent in the capitalist system, spilled over into works of art. The beginning of the 20th century saw the rise of the art market that still prevails today as a closed system based on such principles as rarity, authenticity, supply and demand, and increase in value. The pressure exerted by these three factors led to the concept of modernism, which sought to escape external bonds and assumed the existence of an inner truth that lay hidden and had to be uncovered layer after layer to arrive at the pure essence of things.

Yve-Alain Bois points out that this linear model implies its own end by definition: "Indeed the whole enterprise of modernism, especially of abstract painting,

Yve-Alain Bois weist darauf hin, dass dieses lineare Modell von Anfang an sein eigenes Ende impliziert: "Tatsächlich hätte dieses Unternehmen der Moderne, insbesondere der abstrakten Malerei, die als ihr Wahrzeichen gesehen werden kann, nicht funktionieren können ohne einen apokalyptischen Mythos."[6] Immer wieder wähnten sich Künstler am "Ende": Duchamp, Rodtschenko, Mondrian, Reinhardt und viele mehr glaubten irgendwann in ihrer Karriere, die endgültige Wahrheit gefunden zu haben, womit eben das Ziel der modernen Malerei erreicht und ihre Weiterexistenz sinnlos geworden wäre. Auf die Frage nach dem Ende der Malerei gibt es die zwei Antworten Ja oder Nein, und beide sind unbefriedigend, weil beide zugleich richtig sind. Ohne Schwierigkeit können wir die Ansicht vertreten, dass es in unserer heutigen Zeit unnötig ist zu malen, weil die grossen Künstler der Moderne bereits alles geleistet haben, oder es ist unmöglich zu malen, weil sämtliche Funktionen der Malerei von den Massenmedien, der Werbung oder den elektronischen Medien übernommen worden sind. Gleichzeitig stellen wir aber fest, dass Malerei von vielen Künstlerinnen und Künstlern immer noch praktiziert und sowohl von der Kritik wie auch vom Markt rezipiert wird.

Den Ausweg aus dieser Pattsituation finden wir, wenn wir Abstand gewinnen und die ganze Angelegenheit von aussen sehen. Das "Ende der Malerei" ist keineswegs eine Katastrophe und überlässt uns auch nicht einem Nichts. Es ist lediglich das Ende einer Malerei,

which can be taken as its emblem, could not have functioned without an apocalyptic myth."[6] Artists have repeatedly felt the "end" was coming: Duchamp, Rodchenko, Mondrian, Reinhardt, and many others believed at some point in their careers that they had found the final truth, which meant the end of the road inasmuch as the objective of modernism had been achieved. There are two answers to the question about the end of painting, yes or no, and neither is satisfactory because both are right. We can easily advance the standpoint that it is no longer necessary to paint because the masters of modernism have already covered all the ground or it is impossible to paint because all the functions of painting are now performed by the mass media, advertising, or electronic communications. However, numerous artists still practice painting and the medium continues to attract the attention of both critics and the art market.

We can discover a way out of this stalemate by standing off and taking a look at the situation from outside. The "end of painting" is not a catastrophe and it does not leave us facing a void; it merely signalizes the end of a form of painting that obeyed the stringent and linear concepts of modernism. Following Hubert Damisch,[7] Yve-Alain Bois draws on the theory of the game to illustrate his argument and distinguishes between the generic

die den strengen und linearen Konzepten des Modernismus gefolgt ist. Im Anschluss an Hubert Damisch[7] zieht Yve-Alain Bois die Theorie des Spiels heran, um dies zu veranschaulichen. Er unterscheidet zwischen der Gattung *Spiel* (beispielsweise Schach) und der einzelnen Partie, dem *Match*. "Diese strategische Interpretation ist streng antihistoristisch: mit ihr wird die Frage zu 'einer nach der Stellung, die dem *Match* 'Malerei', wie man es zu einem bestimmten Moment und unter bestimmten Umständen gespielt *sieht*, zugeteilt wird, und zwar in Bezug auf das *Spiel* mit demselben Namen.'"[8] Das *Spiel* "Malerei" ist somit ein offenes; bestimmt ist nur eine elementare Spieltechnik und die Beschaffenheit des Spielfelds: Farbe appliziert auf einen mehr oder weniger flachen Träger. Weitergehende Regeln wie ein Gebot der Reduktion, der Innovation, der Authentizität gehören zum *Match* "Moderne Malerei". Ob das *Match* "Moderne Malerei" zu Ende ist, soll hier nicht näher untersucht werden.[9] Ich gehe aber davon aus, dass die Künstler, denen wir uns hier widmen, an diesem *Match* nicht teilnehmen (allenfalls als Zuschauer), sondern im Rahmen des *Spiels* "Malerei" ihre eigenen Regeln erfinden und neue *Matchs* austragen.

"IN THE POWER OF PAINTING"[10]

Dass die Künstler damit wieder am Nullpunkt der Malerei angelangt seien, wie verschiedene Stimmen meinen, ist eine Ansicht, die noch im-

game *(chess, for example) and the specific* match. *"This strategic interpretation is strictly antihistoricist: with it, the question becomes 'one of the status that ought to be assigned to the* match *'painting,' as one sees it being played at a given moment in particular circumstances, in its relation to the* game *of the same name.'"*[8] *The* game "painting" *is therefore open-ended; only the elementary playing techniques and the type of playing field are defined: paint applied to a more or less flat support. Further rules, such as the requirement of reduction, innovation, or authenticity belong to the* match *"modern painting." I do not wish to address the issue of whether or not the* match *"modern painting" has come to an end.*[9] *Instead, I am going on the assumption that the artists under discussion here are not participants in this* match *but at most spectators and they have invented their own rules within the framework of the* game "painting" *for the new* matches *that they are playing.*

"IN THE POWER OF PAINTING"[10]

The much-voiced notion that artists have thereby come full circle is still part and parcel of the modernist canon. Naturally a certain vacuum exists and some rules are not clear, such as the objective of the match. *Possibly its meaning lies in pursu-*

mer dem modernistischen Gedankengut verpflichtet ist. Natürlich besteht ein gewisses Vakuum, manche Regeln sind nicht klar, beispielsweise, was das Ziel der Spielpartie ist. Vielleicht liegt ihr Sinn darin, einen spannenden Weg zu gehen, eine Zeit lang Spass zu haben, andere *Spiele* oder andere *Matchs* nachzuahmen, solange etwas zu probieren, bis man scheitert. Alles ist möglich. An diesem Punkt standen alle hier vertretenen Künstler anfangs ihrer Karriere. Das *Spiel* hiess und heisst aber immer noch "Malerei", eine durch ihre im Lauf der Geschichte erlangten Errungenschaften und Ideologien mächtige Disziplin. *In the Power of Painting*, innerhalb des Kraftfelds und Machtgefüges der Malerei befinden sich sämtliche malenden Künstler. Ob sie im *Match* namens "Moderne" mitspielen wollen oder nicht: Sie alle unterliegen zusätzlich der *Power of Modernist Painting*, denn diese Ausprägung ist im 20. Jahrhundert zum grundlegenden Schaffensprinzip geworden und hat auch die Kriterien zur Beurteilung von Kunst geliefert.

Alle Künstler, denen sich diese Publikation widmet, wollten sich – sei es zu Beginn ihrer Karriere oder erst später – von diesen Dogmen befreien. Sie standen zweifach im Bann der Malerei: Einerseits (noch) gefangen im System des Modernismus, andererseits fasziniert vom Medium Malerei an sich und überzeugt von dessen Potential. Von der Malerei bezogen sie aber auch ihr Selbstverständnis und von ihrer kontinuierlichen Arbeit die Ermächtigung zur Erneuerung dieser Gattung.

ing exciting paths or having fun imitating other games *and* matches *for a while or even experimenting to the point of failure. Everything is possible. At this point all of the artists represented here were just launching on their careers. The name of the* game *was and still is "painting," a mighty discipline whose power rests on its ideologies and what it has achieved in the course of its history.* In the Power of Painting: *all of these artists have played a role in the energy and strength that emanates from this force field. Whether or not they wish to join the* match *known as "modernism," they have all been subject in one way or another to the* power of modernist painting, *as the salient principle in the development of 20th century art and the source of the criteria that now prevail in evaluating it.*

At one time or another in the course of their careers, all the artists to whom this publication is devoted sought to liberate themselves from these dogmas. They were doubly under the spell of painting: on one hand, they were (still) caught up in the system of modernism; on the other hand, they were fascinated with the medium of painting per se and convinced of its potential. But painting was also the source of their own vision and their continuing work gave them the authority to renew the medium.

The power of painting was felt not only by the makers of art but also by its

The Power of Painting wirkt aber nicht nur auf die Kunstschaffenden, sondern ebenso auf die Rezipienten. Das Gemälde ist wegen seiner praktischen Eigenschaften das Hauptgut des heutigen Kunstmarkts: Es ist handlich, in der Regel dauerhaft und kann neben seiner Funktion als Wertträger auch noch dekorative Aufgaben übernehmen. Dass das Gemälde seine Betrachter auch auf der nicht materiellen Ebene immer wieder zu faszinieren vermag, liegt wohl daran, dass es seine Künstlichkeit, sein Geschaffensein nie ganz verbergen kann; es ist immer (Ab-)Bild und Objekt zugleich. Diese Ambivalenz, die sich nicht zuletzt vom Widerstand des Materials nährt, besitzt ein grosses semantisches Potential. Es eröffnet dem Künstler Spielräume und dem Betrachter Interpretationsräume.

Ein romantisches Zeugnis von der Macht der Malerei gibt Picassos berühmtes Diktum "Die Malerei ist stärker als ich; sie heisst mich tun was immer sie will."[11] Ob man nun vor ihr kapituliert, wie Picasso, oder sich an ihr reibt, von ihr herausfordern lässt, wie die hier gezeigten Künstler: Nichts deutet auf ein bevorstehendes Ende der Malerei hin.

beholders. Because of their practical features, paintings are the main commodity in the art market today: as a rule, they are manageable in size, enduring, and, in addition to their use as an investment, they can perform a decorative function as well. That paintings continue to fascinate beholders beyond the material level probably rests on the fact that they can never quite conceal their artificiality, or rather, the fact of having been made: they are always picture (depiction) and object at once. This ambivalence, additionally nurtured by the resistance of the material, possesses great semantic potential. It gives the artist creative and the beholder interpretive latitude.

What more romantic testimonial to the power of painting than Picasso's famous statement, "Painting is stronger than I am; it makes me do whatever it wants."[11] But whether the artist capitulates, like Picasso, or faces the challenge head on and confronts painting, as do the artists gathered together here, there is no indication whatsoever of an imminent end of painting.

"LÖSUNGEN" 2. TEIL

Mit der Zusammenführung von Warhol, Polke, Richter, Twombly, Marden und Bleckner soll keinesfalls eine neue Schule oder ein weiterer Ismus der Malerei konstruiert werden. Wir meinen auch nicht, diese Auswahl sei repräsentativ

"SOLUTIONS" PART 2

The combination of Warhol, Polke, Richter, Twombly, Marden, and Bleckner is not intended to constitute a new school or invent another "ism." Nor do we wish to imply that this choice is representative of what

dafür, was auf dem Gebiet der Malerei in den letzten fünfzig Jahren hervorgebracht worden ist. Wir sind aber überzeugt, dass diese Künstler abseits der Pfade des Modernismus Bedeutendes geleistet haben. Die Auswahl der einzelnen Gemälde lenkt unseren Blick bewusst auf die frühen Schaffensperioden, um den Weg, den die Künstler zur Erlangung ihrer "Lösungen" gegangen sind, nachvollziehbar zu machen. Damit wird man natürlich in keiner Weise den Gesamtwerken gerecht, die insbesondere bei Warhol, Richter und Polke äusserst komplex sind und weder in der hier gebotenen Kürze, geschweige denn ausschliesslich aus dem Fundus einer einzigen Sammlung angemessen wiedergegeben werden können. Obwohl wir bei Twombly den grösseren Teil seines Lebenswerks ausblenden, sollte die dichte Gemäldefolge, die mit seinem ersten noch erhaltenen Leinwandbild aus dem Jahre 1949 beginnt und bei seinem bahnbrechenden *Ferragosto*-Zyklus von 1961 endet, seine künstlerische Haltung über diese Dekade hinaus zu erhellen vermögen. Brice Marden begleiten wir bis 1986, dem Zeitpunkt als seine teilweise auf der fernöstlichen Kalligraphie basierenden Linienkompositionen, die sich in seinem zeichnerischen Schaffen bereits Jahre zuvor manifestieren, auch Eingang in sein malerisches Werk finden. Obwohl Ross Bleckners künstlerische Bedeutung noch nicht im selben Mass gefestigt ist wie die seiner hier versammelten älteren Kollegen, ist es uns ein Anliegen, mit ihm einen Künstler dabei zu haben, der in den 80er Jahren gross gewor-

has been produced in the field of painting over the past fifty years. We are, in fact, convinced that the remarkable achievements of these artists largely lie beyond the trodden paths of modernism. In the choice of specific paintings, we have intentionally focused on the artists' early periods in order to make manifest the new territory the artists have charted in pursuit of their "solutions." We have no intention of addressing their œuvres as a whole: they are extremely complex, especially in the case of Warhol, Richter, and Polke, and could hardly receive adequate treatment within the parameters of the present project, not to mention the limitations of a single collection. Although we exclude the greater part of Twombly's lifework, the dense series of paintings, beginning with the first still existing painting on canvas of 1949 and ending with his pioneering Ferragosto cycle of 1961, offers insight into his artistic attitude in later years. We accompany Brice Marden until 1986, at which point his line compositions—prefigured in his drawings many years earlier and based in part on the calligraphy of the Far East—make an appearance in his paintings as well. Although Ross Bleckner's artistic significance has not yet been consolidated to the same extent as that of his older colleagues in this publication, we recognize the importance of including him as an artist whose seminal development took place in the eighties, a tur-

den ist, einer Zeit, die aus damaliger Sicht turbulent, aufregend und euphorisch war, aus der heutigen Distanz aber recht kritisch betrachtet wird.

Trotz der Absicht, das Individuelle im Werk der Künstler hervorzuheben, wird Verbindendes sichtbar, und dieses hat seine Grundlagen in der gemeinsamen Haltung, sich den Regeln des Modernismus zu verweigern. Dazu gehört in erster Linie die Vereinnahmung von Strategien, Techniken und Inhalten, die vom Modernismus als Bedrohung der Kunst angesehen wurden:. Das Fotografische, das reproduzierte Bild, industrielle, unpersönliche Herstellungstechniken, Alltagsgegenstände und Konsumgüter, aber auch das bewusste Spiel mit dem kommerziellen Aspekt des Kunstwerks. Andy Warhol ist dafür das Paradebeispiel. Der von ihm dominierten Popkunst werden auch Richter und Polke zugerechnet. Und dabei ist es wiederum interessant, in den Gemeinsamkeiten die Unterschiede zu sehen, die nicht zuletzt im geographischen und kulturellen Umfeld der Künstler liegen: Warhol spielerisch, "cool", scheinbar oberflächlich; Richter konzeptuell, systematisch, beharrlich; Polke geschichtsbewusst, tiefgründig und witzig zugleich. Andere verbindende Aspekte betreffen die Beschäftigung mit dem Material und der Oberfläche des Gemäldes. Bei allen diesen Künstlern geht es gleichermassen um ein Spiel der Schichten, um die Frage, was vorne und was hinten ist, was auf der Oberfläche und was in der Tiefe ist, um Zuschütten und Aufdecken.

bulent, exciting, euphoric decade for those who were part of it, but viewed in restropect with a rather critical eye.

Despite the objective of emphasizing the individuality of these artists, their work shows common ground, observable in their shared attitude of rejecting the rules of modernism. To this end, they incorporate strategies, techniques, and subjects that modernism viewed as a threat to art: photography, the reproduced image, industrial and impersonal techniques of production, everyday objects, consumer goods, and the playful exploitation of the commercial aspect of artworks. Andy Warhol is the example par excellence of these developments. The Pop art classification, with Warhol the dominant exponent, has also been assigned to Richter and Polke. On the other hand, it is interesting to note the divergence in this shared attitude, which lies, among other things, in the geographical and cultural background of the artists: Warhol, playfully "cool" and playing on superficiality; Richter, conceptual, systematic, persevering; Polke, historically minded, profound, and witty at once. Other shared qualities include a concentration on the materials and surfaces of paintings. All of these artists are interested in the play of different layers, in what is in front and what is in back, what is on the surface and what is in the depths, in covering up and uncovering.

Bei aller scheinbaren Unverbindlichkeit prägen die grossen klassischen Themen immer noch die Inhalte: Leben und Tod, Geschichtlichkeit und Mythos. Die Antworten fallen aber nicht mehr eindeutig aus, die absolute Wahrheit gibt es nicht mehr. Die Künstler verzichten darauf, die autoritative Haltung, die der Kunst lange zugedacht war, weiter einzunehmen. Ihre Werke sind offen, mehrdeutig und voller Fragen. Sie fordern uns auf, unsere eigenen, individuellen Antworten und "Lösungen" zu finden.

No matter how uncommitted they may seem to be, these artists address the great classical issues as well: life and death, history and myth. But with a difference: their answers are not final, there is no absolute truth any more. They have surrendered the authority once invested in art and the artist. Their works are open, ambiguous, full of questions. They challenge us to find our own, individual answers and "solutions."

Die Intensität der Distanz

Warhol, Richter, Polke

The Intensity of Detachment

Warhol, Richter, Polke

Sören Engblom

Seit dem Ende der 50er Jahre und bis zum heutigen Tag stehen die Namen Andy Warhol, Gerhard Richter und Sigmar Polke für drei wichtige Wege in der Malerei. In vielen Hinsichten sind sich die drei ähnlich: Sie kamen alle in den 60er Jahren zum künstlerischen Durchbruch; ihr Interesse gilt – was ihre Bilder, das Material und die Themen betrifft – vor allem dem Alltäglichen; ihre Werke sind sowohl figürlich als auch abstrakt oder eine Kombination von beidem; die Künstler richten ihr Augenmerk auf die Bildoberfläche; und die Kontextualität wird stark betont: Geschichtliches, Zeitgeschehen und Kultur in verschiedenen Formen. Auch ein Misstrauen haben sie gemeinsam, um nicht zu sagen eine ausgesprochene Distanzierung vom Denken in subjektiven und ichbezogenen Bahnen. Anfangs der 60er Jahre war die Zeit reif, sich vom Individualismus und der Egozentriertheit, die mit dem Abstrakten Expressionismus verknüpft waren, abzuwenden. (In gewisser Weise gilt diese Charakterisierung auch für die informelle Malerei, obwohl, wie beispielsweise bei Henri Michaux, auch das Gegenteil der Fall sein kann.)

When considering painting from the late fifties to the present, it becomes clear that Andy Warhol, Gerhard Richter, and Sigmar Polke represent three important and distinct directions. The similarities between these artists are many: all had their breakthroughs in the sixties; all were interested in the images, materials, objects, and events of everyday life; and all produced images both figurative or abstract, and—in certain cases—a combination of both. One sees a recurrent focus on the pictorial surface and a marked sense of contextuality throughout their collected works: past, present, and culture are presented in different forms; there is a distrust of—not to mention an aversion to—subjective, individualist, and egocentric thought. Such are the factors that link these artists together, especially when seen against the backdrop of the period when they first entered the art world. Simply put, in the beginning of the sixties, the art world felt it was time to abandon the pre-

Die Kulmination der abstrakten Malerei in der Nachkriegszeit schuf einen Zustand der Sättigung und – wegen ihrer apolitischen Haltung – gleichzeitig eine Art Vakuum. Beides mussten die Künstler überwinden, was besonders für die jungen deutschen Maler ein beachtliches Problem dargestellt haben dürfte. Ob sie wollten oder nicht, sie mussten sich mit ihrem geschichtlichen und kulturellen Erbe auseinandersetzen. Ansonsten würde die Vergangenheit zu einer bedrohlichen Spuk- und Schattenwelt mutieren.

Die neue Generation musste eigenständige Wege finden, sich auszudrücken. In den 60er Jahren hiess dies, sich dem Alltäglichen, Einfachen und vor allem dem Populären anzunähern. Der moderne Zeitgeist kam in der stark verknappten Sprache der minimalistischen Poesie, in politisch geprägter Literatur, im Theater, im französischen cinéma vérité zum Ausdruck, aber auch in der amerikanischen und britischen Volksmusik, die dazumal gerne mit Rockmusik vermischt wurde (beispielsweise wenn Bob Dylan zur elektrischen Gitarre überwechselte).

Andy Warhol wurde schnell zum Inbegriff der Popkunst, während Gerhard Richter und Sigmar Polke 1963 anlässlich eines Happenings den genialen Terminus "kapitalistischer Realismus" erfanden, der – insbesondere für Richter – einer Befreiung gleichkam. Die Begegnung mit Pop und Fluxus ermöglichte ihm, sich vom Sozialistischen Realismus des Ostens zu lösen.

Die Gemeinsamkeiten der drei Künstler liegen also in den Einflüssen des Zeitgeists, der

occupation with the egocentric filter of self that had come to be associated with Abstract Expressionism (and, to a certain extent, informal painting as well, although in some cases, the exact opposite may also hold true, as with Henri Michaux).

The culmination of abstract painting during the postwar years sated the art world, left it full and slow, with artists struggling to overcome the inertia. Through its apolitical attitude, abstract art, as the dominant movement, also caused a vacuum in the years following the war, a vacuum that must have proved especially problematic for young German painters, who could not ignore the legacy of the war in their work. Without incorporating or coming to terms with this past, it would eventually be transformed into a threatening shadow world of hidden ghosts and closet skeletons.

This new generation also had to find unique and individual means of expression, and as with most forms of culture during the sixties, they turned their attention to the everyday world of ordinary things, above all popular culture. Minimalist poetry, political literature and theatre, French cinéma vérité, and American (as well as British) folk music combined with rock (Bob Dylan's switch to electric guitar, for example) all expressed the spirit of the sixties. In time, Andy Warhol "became" Pop Art while, at a happening,

politischen Bewegungen, der Massenkultur und der Medien auf das allgemeine Bewusstsein in den emanzipatorischen 60er Jahren. Heute lebt dies alles nur noch in der Erinnerung, als erlebte "Wahrheit", die immer mehr zum Mythos wird. Gemeinsam ist Warhol, Richter und Polke ausserdem, dass ihre Bildung in der Moderne des 20. Jahrhunderts wurzelt, worin wiederum der Grund für ihre distanzierte Haltung gegenüber den Dogmen des Modernismus liegt, sprich Linearität und Reinheit, gepaart mit einem Hang zu naiver Subjektivität. In einer anderen Situation befinden sich die jungen Künstler von heute. Sie sind kaum mehr von der modernistischen Grundauffassung abhängig, die für die ältere Generation unausweichlich war. Sie halten sich beispielsweise in ihrer Einstellung zur Bilderflut der Massenmedien vor allem an Warhol. Der heutige postmodernistische Zustand bedeutet nicht mehr Aufbruch, egal ob man ihn als ein Stadium der Moderne betrachtet oder nicht. Wir haben einfach weitergeblättert und befinden uns im nächsten Kapitel.

Warhol, Polke und Richter teilen mit jenem Zeitgeist aber nicht nur die Voraussetzungen, sondern auch die erklärte Absicht, sich damit auseinanderzusetzen. In der Art der Umsetzung heben sie sich aber deutlich voneinander ab, und zwar besonders im Hinblick auf Methode, Technik, Ansatz und Temperament, aber auch was die Stimmlage betrifft. Ein Amerikaner und zwei Europäer – der unterschiedliche kulturelle Hintergrund ist nicht zu übersehen.

Sigmar Polke and Gerhard Richter invented the ingenious term "Capitalist Realism" to represent the liberation (primarily for Richter) from the Social Realism of the East through the meeting of Pop and Fluxus in the West.

The three artists thus shared the liberating zeitgeist of the sixties, its political movements, and the rampant spread of mass culture and the mass media. Today, it is a memory, a "truth" in the process of becoming a myth. These artists also share an educational background rooted in 20th century modernism, which meant finding a means of distancing themselves from modernism's entrenched belief in linearity and purity, and its penchant for naive subjectivity. In contrast, young artists today have cast off the bonds of modernism and assimilated the revolutionary attitude towards the mass media introduced by artists like Warhol. The post-modern condition today, regardless of whether it is viewed as a stage of modernism or not, is no longer revolutionary; we have, quite simply, moved on to the next chapter.

Warhol, Polke, and Richter not only share a zeitgeist of upheaval and change but also the avowed desire to explore and confront it. However, in addressing the reality of these conditions, they follow distinct paths. Their approach, technique, temperament, and viewpoint diverge substantially. One American and two Euro-

Die Faszination für das Äusserliche und die Oberfläche, der lustvolle Gebrauch und Verbrauch von Konsumgütern sowie das Wissen um die Tatsache, dass sich alles kopieren, neu schaffen oder verändern lässt, waren in den frühen 60er Jahren in der westlichen Welt weit verbreitet. Andy Warhol brauchte also nur "vor die Haustür zu gehen", um aus dem nie versiegenden Strom der Produkte, Bilder und Ereignisse zu schöpfen. Die visuelle Umsetzung erfolgt nach Massgabe der verschiedenen Massenmedien, sei es in Form von Annoncen, Warenzeichen, Etiketten und Designprodukten, oder durch Zeitung, Film und Fernsehen. Ist ein Körper abgebildet, wie im frühen Gemälde *Where is your rupture?*, (ca.1960) so stammt das Vorbild aus einer Annonce, die deutlich erkennen lässt, wo die ideale Schönheit einen Sprung hat. Mit den Abbildungen von *Liz Taylor*, *Elvis Presley* und anderen Hollywoodgrössen macht Warhol klar, dass Schönheit immer das Resultat eines Herstellungsprozesses ist, zustande gebracht durch Gesten, Posen, Frisuren – Wirklichkeit als Regieprodukt; man gibt sich gar nicht erst der Illusion hin, Schönheit könne von innen her kommen.

Folgerichtig wird dann auch *Mona Lisa*, die Diva der Kunstgeschichte, auf eben diese Art reproduziert: In klaren Primärfarben und vielfach wiederholt. Eigentliches Sinnbild des Austauschbaren und Repetitiven sind Andy Warhols Gemälde von Dollarscheinen. Unser Blick auf die Wirklichkeit wird durch den Gebrauch der Ausdrucksmittel der Massenmedien

peans — one cannot ignore the differences in their cultural backgrounds.

The fascination with externals, the delight in conspicuous consumption, and the knowledge that anything can be copied, reproduced, or recreated deeply affected consciousness in the West in the early sixties. Andy Warhol had a never-ending stream of products, images, and events at his disposal. Whatever the medium (advertising, labels, logos, money, or designer goods) or whatever the vehicle (press, film, television), Warhol invariably worked through the mass media. When a body is depicted, as in the early painting Where is your rupture? *(ca. 1960), the source of the image is an advertisement that clearly reveals the cracks in the ideal of beauty. His renditions of beautiful, handsome Hollywood stars, Liz Taylor or Elvis Presley, always underscore the constructed aspect of beauty: a creation consisting of gestures, poses, hairstyles, and make-up. It is a staged reality that harbors no illusions whatsoever about beauty being a quality that comes from within.*

Thus, the Mona Lisa, *the diva of art history, is naturally subjected to typically Warholian treatment, reproduced many times over in strong primary colors. The quintessential symbol of exchangeability and reproduction, however, is found in Warhol's paintings of American dollar*

gefiltert, die wiederholte Vorführung des Gleichen schafft Distanz. Warhol bietet auch seine Kunstwerke wie Produkte dar. Ihre einfachen, klaren und leeren Strukturen, die sich auf das Äussere, auf die Oberfläche konzentrieren, provozieren zunächst die Einbildungskraft des Betrachters, um dann die Mechanismen des Sehens und Betrachtens blosszulegen.

Eine konstruierte Schönheit findet sich auch in *Do-It-Yourself (Sailing Boats)*, einem Seestück von 1962 zum Selberausmalen nach Zahlenanweisungen. Hier ist die Wiederholung nicht nur unvermeidlich, sondern sogar wünschenswert. Die konstruierte Wirklichkeit ist dermassen unkompliziert, dass jedermann sie nachmachen kann: Do it yourself! Ein immer gleichbleibendes Produkt für alle. Ob der Präsident der Vereinigten Staaten oder der Nachbar um die Ecke – sie alle trinken die gleiche Coca-Cola.

Warhols stilistischer Weg führt vom individualisierenden Medium der Handzeichnung zu immer unpersönlicher werdenden, schliesslich rein mechanisch produzierten Werken. Er arbeitet zunächst mit Stempeln, dann mit Siebdruck, aber auch mit Fotografie und Film. Sein Atelier wird zu einem sozialen Tummelplatz für Mitarbeiter und Bekannte. Naheliegend nennt er es *The Factory*. Obwohl der kreative Schaffensprozess oft einem reinen Herstellungsprozess weichen muss, findet man im Rückblick in seinem Werk deutliche Spuren von Individualität. Warhol selber spricht von seiner "Gesellschaftskrankheit" und meint damit die Sucht, gesehen zu werden, um existieren zu können. Er hat eine

bills. Reality is filtered through the expressive potential of the mass media; the device of repetition generates detachment. Indeed, Warhol offers his artworks as if they were products for consumption. Their simple, clear and empty structures that focus on surface and external appearance would seem an affront to the imagination were it not for their relentless exposure of the mechanisms of seeing and viewing.

The construction of beauty is also manifest in Do-It-Yourself (Sailing Boats), a paint-by-numbers seascape of 1962. Here, repetition is not merely unavoidable, but in fact desirable. And this constructed reality is so simple that anyone can participate: Do it yourself! A product that is the same for all. As Warhol pointed out, Coca-Cola is Coca-Cola even when the President drinks it.

Warhol moves from the individualized medium of works on papers towards increasingly impersonal and finally mechanically reproduced works, first using stamps, then silk-screen prints, photography, and film. His studio becomes a social vortex for acquaintances and colleagues alike. Naming the studio "The Factory" is the logical consequence of identifying the act of creating with the act of manufacturing. Yet, looking back at his work, one can see clear signs of a very individual consciousness. Warhol himself speaks of

unglaubliche Medienpräsenz, die ihm paradoxerweise – so unpersönlich er sich auch gibt – ein recht klares und individuelles Image verleiht.

Der nie endende Strom der Produkte – seien es Bilder von Gegenständen oder Menschen – bildet in Warhols Werk gleichsam als Vanitasmotiv eine Art Konstante. Explizit kommt dies in den Gemälden zum Ausdruck, die Suizide, Autounfälle, Bürgerunruhen, den elektrischen Stuhl zeigen, und natürlich in seinen Totenkopfbildern. "Ich erkannte, dass alles, was ich machte, mit dem Tod zusammenhing." Diese Worte hallen wie ein Echo über sein gesamtes Werk. Die Fortsetzung ist "cool" und mutet mehr wie eine Beschwörung an: "Aber wenn man ein grausiges Bild immer wieder sieht, hat es eigentlich gar keine Wirkung."[12]

Distanziert sich Warhol durch den unpersönlichen und repetitiven Charakter seiner Massenbilder, so ist es bei Gerhard Richter der malerische Prozess per se, der die traditionelle Subjektivität auf Abstand hält. Das klingt paradox, denn die älteren seiner ursprünglich Amateurfotos und Pressebildern entnommenen Motive scheinen doch gerade durch ihre Faktizität den Charakter von Erinnerungsbildern zu besitzen, von Vergangenheit und privater, wenn auch unpersönlicher Bewusstheit. Richters Strategie liegt darin, dass er zwar *jemanden* sehen lässt, aber man kann sich nicht vorstellen, *wer* das ist. Der Künstler unterdrückt dieses Subjekt, indem er seine Bilder leicht verwischt und ihnen so einen Hauch von Unschärfe verleiht, als ob man die

his "social disease," meaning the need to be seen in order to exist. He willingly submits to being turned into a media event, where he paradoxically makes a distinctive, highly individual impact despite his impersonal, detached attitude.

In the ceaseless flow of products, whether they represent people or things, one discovers a constant that might be compared to a vanitas motif, as manifest in the subject matter of his paintings: suicide, car crashes, rioting, the electric chair, and, of course, his skulls. "I realized that everything I was doing was related to death." These words reverberate through Warhol's entire œuvre and, as if in calm invocation, he goes on to say: "But when you see a gruesome picture over and over again, it doesn't really have any effect."[12]

While Warhol establishes distance through the impersonal and repetitive nature of the mass-produced image, Gerhard Richter turns to the painting process per se to keep traditional subjectivity at bay. This poses a paradox since the facticity of his early subject matter, taken from amateur photographs and newspaper pictures, addresses issues of memory, of the past, and of an individual, even if impersonal, conscience: someone *sees*, but we cannot imagine *who*. We are confronted with images that seem to be filtered through a blurred, transparent membrane as if to re-

dargestellte Welt durch einen Filter betrachtete, der nur noch den Schatten einer unbekannten Subjektivität erahnen lässt.

Gerhard Richters umfassendes Werk enthält sowohl zeitgenössische als auch klassische Motive: Pressebilder, Architektur, Altmeistergemälde, Blumen, Landschaften und Familienbilder. In seinem Œuvre ist die deutsche Nachkriegszeit aufgezeichnet: Hier ist der Alltag innerhalb und ausserhalb der Bürogebäude mit ihrer typischen, unpersönlichen Architektur; da die Täter und Opfer von mehr oder minder politisch gefärbten Verbrechen, und dort die stillen, ebenso mystischen wie neutralen Nebellandschaften, denen ein verborgener Sinn unterlegt zu sein scheint. Inmitten dieser reich facettierten Bilderwelt tauchen dann plötzlich und immer wieder seine grauen, monochromen Bilder und die neutralen Farbtafeln auf. Sie nehmen in der Welt seiner Motive gleichsam eine Nullposition ein.

Sein Quellenmaterial sammelt Richter seit 1962 und fasst es in einem gesonderten Werk zusammen, das den Titel *Atlas* trägt. Diese Bilder und Fotografien stellen nicht nur für seine Malerei, sondern auch für das von ihm beobachtete Nachkriegsdeutschland ein wertvolles Archiv dar. Über die Wahl seiner Motive spricht sich der Künstler nicht aus. Statt dessen redet er lieber von der Malerei, und zwar als einer hochentwickelten Disziplin, die Gefahr läuft, auszusterben, weil spezifische Fachkenntnisse dem Vergessen anheimzufallen drohen. Das zu verhindern betrachtet er als seine Pflicht. Und er

veal only the shadows of an unknown subjectivity.

Gerhard Richter's prolific body of work spans contemporary and classical motifs: press photography, architecture, classical paintings, flowers, landscapes, and family portraits. His œuvre presents a picture of Germany primarily after the war, from the day-to-day life inside and outside office buildings with their typically faceless architecture to the victims and perpetrators of more or less politically motivated crimes or the motionless, both mystical and neutral, misty landscapes that seem to brood over some hidden meaning. This richly faceted imagery is repeatedly broken by the gray monochrome paintings and neutral color charts which constitute a kind of zero-position within the world of Richter's motifs.

Since 1962 Richter has collected his source material in a separate work titled Atlas. These images and photographs represent valuable archives that offer insight into his paintings but also into his view of postwar Germany. Richter says little about the motivation behind his choice of motif; he prefers to speak about painting and the fact that this sophisticated discipline is threatened with extinction if the necessary skills and expertise are no longer cultivated. He considers it his duty to counteract this development. He and painting are mutually dependent: without

steht mit der Malerei in einem gegenseitigen Abhängigkeitsverhältnis, denn ohne sie könnte er die Flut der Bilder von damals und heute zwar wahrnehmen, aber nicht verstehen. Gleichzeitig hat er das Bedürfnis, das Arbeitsfeld, das er malend bestellt, zu erweitern.

Die Grenzen zwischen Figuration und Abstraktion sind fliessend. Seine abstrakten Gemälde wirken oft wie Ausschnitte aus Landschaftsbildern, wie ein bewegter Tizianhimmel oder wie lichte Wolkengebilde. Sie geben aber auch unmittelbar Zeugnis vom Kampf des Künstlers mit dem Zufall. So kommt es beispielsweise in der grossen Bach-Suite (1992) zur Konfrontation zwischen den sorgfältig geplanten Farbschichten und der unberechenbaren "Offenbarungsarbeit" des Spachtels.

Die hier gezeigten Gemälde – *Frau mit Schirm*, *Rokokotisch* (beide 1964), *Stadtbild D* (1968) und *Feldweg* (1987) – sind durch den malerischen Prozess miteinander verbunden. Er verleiht der Bildoberfläche eine membranartige Qualität, welche Vergangenheit und pulsierende Gegenwart Zeitschichten gleich miteinander verwebt. Richter beschreibt die Malerei als eine Form des Hoffens. So gesehen wirkt der Malakt wie eine Gegenkraft gegen den unaufhaltsamen Zeitablauf. Nicht erstaunlich, trifft man auch bei ihm auf Vanitasmotive, auf die brennende Kerze und natürlich den Totenkopf. In Bezug auf den Malakt liegt das erste gemeinsame Charakteristikum von Richters Werk in der Konzentrationsfähigkeit des Künstlers. Und Konzentration findet immer *hier* und *jetzt* statt.

it, he would perceive but not comprehend the flood of images, both present and past. On the other hand, he is driven to increase the area that he covers with his painting.

The distinction between figuration and abstraction is blurred. His abstract paintings often look like fragments of landscapes: the low-hung skies of Titian, perhaps, or light cloud formations. But they also testify to the artist's bold combat with chance as his opponent. In the large Bach suite (1992), for example, the carefully planned application of paint encounters the palette knife's less predictable act of revelation.

The paintings on view here—Frau mit Schirm and Rococo Table (both 1964), Stadtbild D (1968), and Feldweg (1987)—are related through the painterly process that transforms the canvas into a membrane of layered time from the past to the pulsating present. Richter describes painting as a form of hope. The act of painting becomes a force that opposes the inexorable course of time. Richter also makes use of vanitas motifs, of the skull and the burning candle, though his artistic approach is entirely different from Warhol's. However, the compelling cogency of Richter's paintings rests above all on the intensity of his concentration, a concentration focused unremittingly on the here and now.

"Wenn wir einen Vorgang beschreiben, eine Rechnung aufstellen oder einen Baum fotografieren, schaffen wir Modelle; ohne sie wüssten wir nichts von der Wirklichkeit und wären Tiere."[13] Dieses oft zitierte Statement, das Gerhard Richter in Bezug auf seine abstrakten Bilder an der *documenta 7*, 1982 machte, betrifft die Mechanismen und die Essenz des künstlerischen Schaffensprozesses. Warhol, Richter und Polke sind auf der Suche nach Modellen für ihre Betrachtungsweise. Diese Modelle sind dann auch das Instrument, mit dem sie sich dem Motiv nähern und gleichzeitig eine naive Subjektivität fernhalten können. Sie wollen sich zur Faktizität des Objekts in Verhältnis setzen und dennoch eine individuelle Verhaltensweise finden.

Diese besteht für Polke darin, dass er sich immer wieder dem Muster zuwendet. Es zeigt ihm, in welcher Art und Weise man sich der Bildwirklichkeit bemächtigen kann. Anders als Warhol und Richter geht Polke nicht von einer ausnahmslos zweidimensionalen Bilderwelt aus, sondern führt mit der Verwendung von Alltagsmaterialien wie beispielsweise Holzspalier, Wolldecken, Baustoff oder Farbe eine weitere Dimension ein. Sowohl das Muster wie auch die Stofflichkeit der Textilien stellen unpersönliche Faktoren dar, die wir für gewöhnlich als Gegebenheiten hinnehmen. Dennoch sind es gerade diese materiellen Eigenschaften, durch die wir ein intimes Verhältnis zu den Dingen erlangen. Aber davon merken wir nichts. Das Muster fällt uns erst auf, wenn es in einem Zusammenhang auftaucht, wo wir es üblicherweise nicht an-

"When we describe a process, or make out an invoice, or photograph a tree, we create models; without them we know nothing of reality and would be animals."[13] This much quoted statement made by Richter in reference to his abstract paintings, exhibited at documenta 7 in 1982, touches upon the mechanics and, indeed, the essence of the creative process. Warhol, Richter, and Polke are all in search of models to serve as instruments in approaching their motifs but also to avoid the pitfalls of naive subjectivity. They want to relate to the facticity of the object but seek individual modes of artistic behavior in achieving their objectives.

For Polke this entails a recurring concern with patterns as symbols and structures of pictorial reality. Unlike Warhol and Richter, who both find their starting point in a strictly two-dimensional world, Polke adds another dimension through the use of everyday materials, such as a wooden trellis, a blanket, building materials, or paint as substance. Both the pattern and the materiality of textiles are impersonal factors that we ordinarily take for granted. We are entirely unconscious of the fact that they frequently act as the basis for an intimate relationship with things. It is not until the pattern appears in an unexpected context, for example, in a painting, that it attracts our attention. One is reminded of the sudden

treffen, beispielsweise in einem Gemälde. Oder wenn wir völlig unerwartet etwas wiedersehen, was verborgen und vergessen gewesen ist. Oder wenn wir, wie Marcel Proust in *Auf der Suche nach der verlorenen Zeit*, ein Madeleine-biskuit in Tee tunken und mit dieser Erfahrung eine ganze Welt wachrufen und wiederfinden.

An ihren Materialien und Mustern lässt sich eine Epoche oder eine Kultur wiedererkennen. Polkes Palmen und Flamingos sind Symbole für den Wohlstand, die Freizeitgestaltung und die Ferienträume der späten 50er Jahre. In der westlichen Wohlstandsgesellschaft breitet sich das Schlaraffenland aus, dringt ein durch die Schleier und Tüllgardinen der Tradition und überdeckt ältere Zeichen und Ornamente, die aufgrund der Geschichte inhaltlich belastet sind wie beispielsweise die Swastika. Wir denken in Mustern, wir durchbrechen unsere Muster, und in unserer Formenumwelt tauchen ständig Muster auf, die Ablagerungen von Bedeutungen und Mythen enthalten. Polke spürt sie auf, bringt sie an den Tag, lässt ihre latenten Bedeutungen durchscheinen, und wir staunen, das zu sehen, was doch eigentlich schon immer da war.

Der Künstler betrachtet diese Motive trotz deren Vielfalt als Einheit. Vor allem in seinem Frühwerk präsentiert sich Polke als drastischer Humorist, sein Werk lebt von Anspielungen, Ironie und Witz und nimmt eine überschätzte Subjektivität und Spontaneität aufs Korn. In diesem Zusammenhang ist auch sein Hang zu Alltagsgegenständen von kulturell geringem Ansehen zu verstehen. Polke enthüllt in den

perception of an object long hidden or forgotten, or the near infinite world of memory evoked by the smell of a madeleine dipped in a cup of tea in Proust's Remembrance of Things Past.

Materials and patterns give us clues to an epoch or a culture. Polke's palm trees and flamingos symbolize the prosperity, recreational activities, and dreams of a vacation paradise in the late fifties. In the affluent society of the West, a land of milk and honey swishes through the veils and muslin curtains of tradition, displacing older ornaments, such as the swastika, still burdened with the weight of history. We think in patterns and we break our patterns, and in the world around us, patterns form a sediment of meanings and myths. Sigmar Polke finds them, digs them up for us to see, and reveals their latent semantic potential, so that we are astonished at being confronted with something that has been there all along.

For Polke, these motifs, though disparate in appearance, form a unified whole. Especially in his early work, he applies his wit to parodying pretentious spirituality and the exaggerated belief in subjectivity or spontaneity, which also explains his penchant for the things of everyday life that have no "cultural" value. In patterns and materials, he discovers a remarkable unity as if there were actually a hidden inner truth in them, a truth that

Mustern und Materialien aber auch eine eigentümliche Einheit, als ob eine innere Wahrheit darin verborgen wäre, nämlich die Wahrheit über unsern Weg nach dem Hier und Jetzt, mit anderen Worten: Über den Verlauf der Geschichte.

Auch viele von Polkes Werken sind nach fotografischen Vorlagen entstanden. Er benutzt dafür manchmal ein vergrössertes Raster, das unweigerlich an Roy Lichtenstein oder Andy Warhol denken lässt. Aber bei Polke verleiht die explizite handwerkliche Qualität dem Raster eine andere Dignität. Es wird zum Widerstand und übernimmt die Hauptrolle im Bild. In seiner reichen Bilderwelt stellen Polkes Muster und Material das exakte Gleichgewicht zwischen dem alltäglich Bekannten und dem fremden Unbekannten her.

Warhol, Richter und Polke stehen für drei Haltungen in der Malerei unserer Zeit, die sich aus demselben Boden nähren. Sie folgen aber verschiedenen Konzepten, was Distanzierung und Einfühlung betrifft: Der Bildwelt der Massenmedien, dem malerischen Prozess und den Mustern unserer Umwelt. Jedem gelingt es auf seine eigene Art, den unermesslichen Bilderstrom unserer Zeit zu nutzen, zu untersuchen und zu kommentieren.

tells us how we have arrived at where we are today, a truth that incorporates the course of history.

Many of his works are based on photographs, enlarged to reveal their halftone dots and thus reminiscent of Lichtenstein or maybe even Warhol. But the explicitly handcrafted quality of the pattern or grid lends Polke's paintings a dignity of a different order. It generates opposition and becomes the focus of the picture. Patterns and materials in Polke's exuberant œuvre maintain an exact balance between the everyday known and the foreign unknown.

Warhol, Richter, and Polke—three directions in contemporary painting, nurtured from the same soil. They follow very different paths in their quest for detachment and insight—the mass media, the painting process, and the patterns of daily life. They each succeed in lending a personal signature to their exploitation of today's ceaseless and immeasurable flow of images.

Spuren des Lebens

Twombly, Marden, Bleckner

Iris Müller-Westermann

Ebenso wie Andy Warhol, Gerhard Richter und Sigmar Polke beschäftigen sich auch Cy Twombly, Brice Marden und Ross Bleckner mit dem Medium Malerei, mit dessen Realität, Sprache und Ausdrucksrepertoire. So wie jene, setzen sich auch diese mit dem Verhältnis von Kunst und Realität auseinander, um in ihren Gemälden eine eigene Bildrealität zu konstruieren, in welcher die äussere Welt ebenso wie persönliche Erfahrungen auf sehr unterschiedliche Weise zum Ausdruck kommen.

Während die gemeinsame Quelle für Warhol, Richter und Polke die Welt der Konsumgüter und die durch die Massenmedien verbreitete Bilderflut sind, haben Twombly und Marden von einem abstrakten Ausgangspunkt aus begonnen, von dem sie sich zu einer Durchdringung der Wirklichkeit in einem bildlichen Schreiben oder einer Bildschrift hin bewegt haben. Ross Bleckner begann Mitte der 70er Jahre zu malen, beeinflusst von der damals vorherrschenden Ästhetik der Minimal- und Konzeptkunst, aber auch inspiriert von konstruktivistischen Tendenzen der russischen

Traces of Life

Twombly, Marden, Bleckner

Not only Andy Warhol, Gerhard Richter, and Sigmar Polke, but also Cy Twombly, Brice Marden, and Ross Bleckner concern themselves with painting—with its reality, language, and expressive repertoire. They, too, explore the relationship between art and reality, in order to construct a pictorial reality of their own, in which both the outside world and personal experience are expressed in very different ways.

However, while Warhol, Richter, and Polke draw on the world of consumer goods and the flood of mass media images, Twombly and Marden take a more abstract point of departure, gradually penetrating reality through images that resemble writing. Ross Bleckner began to paint in the mid-seventies. At the time, he was influenced by the dominant aesthetic of Minimalism and Conceptual art, but was also inspired by the Constructivist tendencies of the Russian avant-garde. While his European colleagues—the Neue Wilden *in Germany and the* Trans-avanguardia *in*

Avantgarde. Während seine europäischen Malerkollegen – die Neuen Wilden in Deutschland und die Transavanguardia in Italien – in den 80er Jahren einem neo-expressionistischem Stil huldigten, entwickelt Bleckner eine Malerei, die zwischen Abstraktion und Figuration oszilliert. Seine Kunst bezieht ihre inhaltlichen Wurzeln aus der Wirklichkeit, die ihn als Homosexuellen in New York umgibt. Diese Welt, die in den 80er Jahren von Krankheit, Aids und Tod dominiert wird, verwandelt Bleckner in Bildmetaphern, in denen Licht und Schatten miteinander ringende Elementarkräfte darstellen.

Cy Twombly ist einer der grossen Erneuerer der Malerei in der zweiten Hälfte des 20. Jahrhunderts, der seinen besonderen und eigenen Stil gefunden hat. Bis heute hat sein Werk viele Künstler seiner eigenen und der nachfolgenden Generationen inspiriert. In den frühen Arbeiten von 1949 bis 1954 setzt er sich als Student mit dem Abstrakten Expressionismus auseinander, über den er ab 1955 hinausgehen wird. An den dann folgenden Werken lässt sich nachvollziehen, wie sich eine Schrift aus dem abstrakten Bilde löst, eine "Handschrift", die als geheimnisvolle und persönliche Mitteilung erscheint. Darüber hinaus lassen sich an diesen Werken wichtige Stadien in Twomblys Kunst nach dem 1955 vollzogenen Paradigmawechsel verfolgen.

Ritual von 1949 ist die frühste noch erhaltene Arbeit auf Leinwand und stammt aus der Zeit bevor der Künstler 1950 von Boston an die Art Students League nach New York wechselte.

Italy—embraced a neo-expressionist style in the eighties, Bleckner developed a style of painting that oscillated between abstraction and figuration. The substance of his art is rooted in the reality of life as a homosexual in New York. Bleckner transforms this world, dominated in the eighties by illness, AIDS, and death, into metaphors in which light and shadow appear to be elemental powers locked in combat with each other.

With his exceptional and distinctive style, Cy Twombly has been one of the greatest contributors to the rejuvenation of painting in the second half of the 20th century. To this day, his work has inspired many artists of his own and younger generations. Between 1949 and 1954, while still a student, he explored Abstract Expressionism, which he left behind in 1955. His ensuing work gives insight into the transition from the abstract image to a form of "handwriting" that appears as a mysterious and personal message. These paintings also show the important stages in Twombly's art that followed the paradigmatic change in 1955.

Ritual (1949), the earliest surviving work on canvas, dates from the period before the artist transferred from Boston to the Art Students' League in New York in 1950. The gestural brushwork and the strong, vibrant colors testify to Twombly's

Der gestische Pinselduktus und die starken, vibrierenden Farben zeugen von Twomblys Auseinandersetzung mit dem Expressionismus, mit dem er sich in Boston an der School of the Museum of Fine Arts beschäftigte. Die Ölfarbe ist in Schichten übereinander gesetzt und bildet eine Gitterstruktur, wobei Teile der einzelnen Schichten wie Sedimente sichtbar bleiben. Die abstrakte Bildstruktur von *Ritual* vermittelt den Eindruck von Bewegung und weckt Assoziationen an eine Gruppe Menschen, die – vereinigt in einem Ritual – sich an den Händen halten und im Kreis um ein Mittelfeld schreiten oder tanzen.

Robert Rauschenberg, Twomblys Kommilitone aus der Art Students League in New York, ermutigte den Freund, sich für den Sommer 1951 am legendären Black Mountain College in North Carolina einzuschreiben, wo der junge Twombly unter Ben Shan und Robert Motherwell studierte. Er verbrachte dort auch das Wintersemester, nun zusammen mit Rauschenberg.

In *Zyxig* (1951), das vermutlich während seines Aufenthalts am Black Mountain College entstanden ist, wird eine formale Reduktion sichtbar, die an primitive Zeichen erinnert. Im Gegensatz zu *Ritual* ist die Farbpalette auf Braun- und Beigetöne reduziert. In seiner Zeichenhaftigkeit erinnert *Zyxig* an Robert Motherwells Kunst aus dieser Zeit und an Franz Klines kalligraphische Abstraktionen in schwarz und weiss, während die mit Sand vermischte Ölfarbe eine erodierte Oberfläche schafft, die an die Art Brut eines Dubuffet denken lässt.

exploration of Expressionism conducted at the School of the Museum of Fine Arts in Boston. Superimposed layers of oil paint build a latticework structure with parts of the layers remaining visible, like sedimentation. The abstract structure of Ritual *conveys an impression of movement, suggesting a group of people who, unified in a ritual act, hold hands and pace or dance in a circle around a central field.*

Robert Rauschenberg, a fellow student of Twombly's at the Art Students' League in New York, encouraged his friend to register for the summer at the legendary Black Mountain College in North Carolina, where the young Twombly studied under Ben Shan and Robert Motherwell. He also spent the winter semester of 1952 there, this time with Rauschenberg.

In Zyxig *(1951), probably painted during his stay at Black Mountain College, a formal reduction—reminding one of primitive signs—becomes visible. In contrast to* Ritual, *the palette is reduced to brown and beige tones. The emblematic quality of Zyxig recalls Robert Motherwell's art of that period and Franz Kline's calligraphic abstractions in black-and-white, while the oils mixed with sand create an eroded surface reminiscent of Art Brut and Dubuffet. In 1956, the then 28-year-old Twombly himself described the roots and origins of his art: "Generally*

"Insgesamt gesehen hat sich meine Kunst aus dem Interesse an abstrahierten, doch gleichwohl humanistischen Symbolen entwickelt; formal, wie es die meisten Künste in ihren archaischen und klassischen Stufen sind, und ein zutiefst ästhetischer Sinn für erodierte und antike Oberflächen der Zeit."[14] Mit diesen Worten beschreibt der 28-jährige Twombly 1956 in einem Rückblick die Wurzeln und Ursprünge seiner Kunst.

Solon I (1952) besitzt im Unterschied zu *Ritual* und *Zyxig* kein in der Mitte liegendes Zentrum, sondern das Gemälde besteht aus einer Struktur phallisch aufstrebender Formen. Die vertikalen, braunen Linien, die oben in ovale und spitzige Formen münden, überziehen das Bild wie ein Zaun. Auch hier ist der in Schichten übereinander aufgetragenen Farbe Erde beigemischt. Assoziationen an eine Feuchtlandschaft mit Rohrkolben stellen sich ein. Wiederum führt Twombly einen Dialog mit dem Abstrakten Expressionismus. Seit seiner Übersiedlung nach New York 1950 hatte der junge Künstler reichlich Gelegenheit, in den dortigen Galerien, die die amerikanische Nachkriegsavantgarde zeigten, Werke von de Kooning, Pollock, Rothko, Newman, Motherwell, Kline und Still zu studieren.

Nach einer fast einjährigen Europa- und Nordafrikareise, die er zusammen mit Rauschenberg unternahm, und die ihn vornehmlich nach Italien und Marokko führte, kam er 1953 als ein Gewandelter zurück: "Es ist schwer, überhaupt nur den Anfang zu machen, wollte ich von den vielen, vielen Dingen erzählen, die ich gesehen

speaking, my art has evolved out of the interest in symbols abstracted, but nevertheless humanistic; formal as most arts are in their archaic and classic stages, and a deeply aesthetic sense of eroded or ancient surfaces of time."[14]

In contrast to Ritual *and* Zyxig, *the composition in* Solon I *(1952) is not organized around a center, but instead consists of a structure of phallic forms. The rising, vertical brown lines, ending at the top in rounded and pointed shapes, travel across the painting like a fence. Here, too, the layered oils are mixed with earth. Associations of a damp, reedy landscape come to mind. Once again, Twombly carries on a dialog with Abstract Expressionism. Since moving to New York in 1950, the young artist had had ample opportunity to study the postwar avant-garde art on view in New York galleries, represented by such artists as de Kooning, Pollock, Rothko, Newman, Motherwell, Kline, and Still.*

After an almost year-long trip to Europe and North Africa with Robert Rauschenberg, during which time they chiefly visited Italy and Morocco, Twombly returned in 1953 much changed: "It is difficult to begin to tell of the many, many things I saw and experienced—not only in art and history, but of human poetry and dimensions in the fleeting moments and flux. I will always be able to find energy

und erlebt habe – nicht nur auf dem Gebiet von Kunst und Geschichte, sondern auch von menschlicher Poesie und Dimensionen im flüchtigen Augenblick und Fluxus. Ich werde immer imstande sein, aus diesen Zeiten Energien und Anregungen zu finden, mit denen ich arbeiten kann. Die Dinge, die ich hinter mir liess, sehe ich jetzt klarer und sogar umfassender. Es war wie ein enormes Erwachen, bei dem man viele wunderbare Räume in einem Haus findet, von dem man gar nicht wusste, dass es existierte."[15]

In *The Geeks* hat Twombly 1955 seine Loslösung vom Abstrakten Expressionismus vollzogen. Er erfindet eine Schreibweise jenseits der Schrift. Die mit beiger Anstrichfarbe grundierte Leinwand, die das Licht des Mittelmeerraumes evoziert, ist mit einem gewebeartigen Lineament aus Bleistift- und Farbstiftstrichen überzogen, einem Gekritzel, das zum Lesen des nicht Lesbaren einlädt. Angeregt durch Kurse in Kryptographie, die er während seines Militärdienstes in Camp Gordon (Augusta, Georgia) besuchte, zeichnete er an den Wochenenden nachts im Dunkeln – ohne Licht – in einer Art surrealistischer *écriture automatique*. Für den Künstler wiesen diese in der Dunkelheit entstandenen Zeichnungen "den zukünftigen Weg der künstlerischen Entwicklung"[16]. Twombly verwischt, übermalt und überschreibt, wobei frühere Schichten als Rudimente durchscheinend sichtbar bleiben. Es gibt kein Zentrum, keine Leserichtung. In *The Geeks* ist die Intimität des Schreibens aufgegeben, wie Katharina Schmidt in ihrem inspirierenden Aufsatz über Twombly

and excitement to work with from these times. I see clearer and even more the things I left. It's been like one enormous awakening of finding many wonderful rooms in a house that you never knew existed."[15]

The Geeks *(1955) ushered in Twombly's definitive departure from Abstract Expressionism. He invented a way of writing that is beyond writing. The canvas, primed with beige house paint, evokes the light of the Mediterranean and is covered with a weave of pencil and crayon strokes, a written scribble that invites one to read the unreadable. Animated by courses in cryptography that he took during his military service at Camp Gordon, Augusta, Georgia, Twombly drew on the weekends at night and without light, creating a kind of Surrealist écriture automatique. In his own words, these drawings done in the dark shaped "the direction everything would take from then on."[16] He erased, painted over, and wrote over, while old layers, like rudiments, remained translucently visible. There is no center, no direction in which to read. The intimacy of writing disappears in* The Geeks, *as Katharina Schmidt remarks in her inspiring 1984 essay on Twombly: "While Pollock had already separated automatism from free association with its literary, surrealistic implications and allowed the act of painting itself to become the actual means*

1984 bemerkt: "Während Pollock bereits den Automatismus von der freien Assoziation mit ihren literarisch-surrealistischen Implikationen gelöst hatte und den Malakt zum eigentlichen Ausdrucksmittel werden liess, übersetzte Twombly spontanes, an kein bestimmtes Alphabet gebundenes Schreiben von kleinen, meist glatten Papierträgern auf grosse, rauhe Leinwände. Die unmittelbaren, persönlichen Merkmale, die sich mehr als in der malerischen Aktion im Duktus der feinen, von der Grossmotorik bestimmten Linien, im Rhythmus und in der Dauer ihrer Bewegungsabläufe ausdrücken, verlieren damit an Intimität, an Privatheit und rücken – bedingt – in den Anmutungsbereich anonymer Graffiti. Ihr höchst subjektiver dringlicher Mitteilungscharakter wirkt so gesehen als sei er, den Witterungsprozessen der Zeitabläufe überantwortet, schon wieder aufgehoben."[17] Twomblys "Geschreibe" zeugt von menschlicher Anwesenheit, die jegliche Allgemeingültigkeit relativiert.

Fasziniert von der mediterranen Kultur siedelt Twombly 1957 nach Rom über. Die Welt des Mittelmeerraumes mit ihren Mythen, ihrer Geschichte und Kunst beginnt eine zentrale Bedeutung in seinem Werk einzunehmen. Im 1959 entstandenen Gemälde *Untitled (Roma)* haben sich die flächendeckenden Linien in graphische Partikel aufgelöst, die die Leinwand als Schnörkel, Kreise und Kringel sowie mit eingeschriebenen arabischen Zahlen überziehen. Ein durchkreuztes Herz lässt sich ebenfalls erkennen, auch ein fensterartiges Gebilde und Zahlenreihen am oberen Bildrand. Es sind flüchtig,

of expression, Twombly transposed spontaneous writing with no connection to any particular alphabet from small, usually smooth paper sheets onto large rough canvases. Direct, personal characteristics are expressed in the small works on paper more by the flow of fine, kinetically determined lines and in their duration than in the act of painting: the paintings lose a degree of intimacy, of privacy, and approach —to a limited extent—the feeling of anonymous graffiti. Their highly subjective, urgent, communicative character gives the effect, when viewed thus, of having been transcended again, in submission, as it were, to the stormy process of passing time."[17] Indeed, Twombly's scribblings testify to an individual presence so strong that it questions the existence of universals.

Fascinated by Mediterranean culture, Twombly moved to Rome in 1957, where the culture, with its myths, history, and art, began to play a central role in his work. In Untitled (Roma) of 1959, the linear fabric has given way to graphic particles; the canvas is covered with curlicues, circles, and squiggles. A crossed-out heart can be recognized as well as a window-like configuration and Arabic numerals inscribed at the top of the painting. We face an array of fleeting signs, seemingly written in haste. There are also more colors. Orange and red pencil and crayon complement the

wie in Eile hingesetzte Zeichen. Auch nimmt die Farbigkeit zu, der Bleistift wird mit orangen und roten Farb- und Wachsstiften ergänzt, ebenso lassen sich dicke und tropfende Farbspuren von Ölfarbe sowie Übermalungen entdecken. Das Bildganze kann nicht mehr mit einem Blick erfasst werden. Auch wenn das Auge die Leinwand sorgfältig abtastet, verweigert das Bild die Zusammensetzung der Teile zu einem homogenen Ganzen – es zeigt Fragmente in einem mehrdeutigen Zusammenhang.

In *Ferragosto I* (1961) sind die graphischen Partikel, die Twombly in *Untitled (Roma)* benutzt hat, grösstenteils durch Farbspuren in Orange-, Rot-, Gelb- sowie Rosa- und Pastelltönen ersetzt, die auf die weiss-beige grundierte Leinwand mit unterschiedlichem Malwerkzeug (auch von Hand) aufgetragen sind. Die pastose Ölfarbe löst nun die kleinfigurigen Zeichen der früheren Bilder ab. *Ferragosto I* vermittelt Bewegung, Leichtigkeit, Heiterkeit, Rhythmus. Das Gemälde führt vor Augen, wie Twombly in gestischer Malerei auf die Atmosphäre der mediterranen Landschaft reagiert, und wie die Farbe nun einen neuen sinnlichen Reiz gewinnt. "Ferragosto" ist die italienische Bezeichnung für das Fest der Maria Himmelfahrt (am 15. August) und gleichzeitig ein Synonym für die Mitte des Hochsommers, den alle Italiener am Meer zu verbringen pflegen. Die Farbflecke und gezeichneten Spuren in *Ferragosto I* bilden keine Landschaft ab, trotzdem ist man aber versucht, sich gegenständliche Vorstellungen zu machen. Links lässt sich ein

graphite; in addition, drippings, thick traces, and layers of oil paint can be discovered. The entire image can no longer be taken in at a single glance, but even when the eye carefully scans the canvas, the image refuses to merge into a homogeneous whole. It shows fragmented parts in an ambiguous correlation.

In Ferragosto I *(1961), the graphic particles that characterize* Untitled (Roma) *are largely replaced by traces of orange, red, yellow, pink, and pastel tones, applied to the white-beige primer with various tools (including the hand). Pastose oils have replaced the small-figured signs of the late fifties.* Ferragosto I *conveys movement, ease, brightness, and rhythm. It shows how Twombly reacts to the atmosphere of the Mediterranean landscape with gestural painting in which colors now have a new, sensual attraction. "Ferragosto" is the Italian for Assumption Day (August 15) and at the same time, a synonym for midsummer, which all Italians take care to spend at the seaside. Although the spots of color and traces of drawing in* Ferragosto I *do not form any sort of landscape, one is still tempted to make figurative associations. On the left, one might imagine a crowded beach, while on the right, a curved line appears to allude to the coastline along the bay. Towards the top of the painting, left of center, two round orange forms can be seen; the bikini bottom*

Strand voller Menschen assoziieren, während eine kurvige Linie rechts auf die Strandlinie der Meeresbucht anzuspielen scheint. Am oberen Bildrand, links der Mittelachse, lassen sich zwei orange, runde Formen ausmachen, die durch eine darunter gezeichnete Bikinihose zu Brüsten werden. Vor unserem Auge entsteht eine sonnenbadende Frau. Der braune Farbstrich oberhalb der "Brüste" deutet gleichsam die Levitation des Frauenkörpers aus dem Bild an. Ist die sonnenbadende Frau zugleich eine himmelfahrende Maria?

"Twombly ... exemplifies the importance of the ... little things that people do compared to a much larger world of all human activities",[18] wie Fairfield Porter 1960 feststellt. Twomblys Gemälde führen aber auch vor Augen, wie wir uns die Welt durch unsere Erfahrungen aneignen. Seine Zeichensprache stellt eine Abstraktion von der direkten, unvermittelten Erfahrung dar. Sie begründet eine hermetische Bildwelt, die von der symbolischen Vermitteltheit menschlicher Existenz handelt und die Möglichkeit wirklicher Kommunikation fraglich erscheinen lässt.

Die hier gezeigten Werke von Brice Marden reichen von den Farbfeld-Bilder über sein *Second Window Painting* von 1983 bis zu *Untitled #1* von 1986 und machen den sich unter dem Einfluss von Glasmalerei und fernöstlicher Kalligraphie und Dichtung vollziehenden Umbruch in seiner Kunst sichtbar.

In *Starter* (1971), *For Hera* (1977) und *Elements I* (1981-82) trägt Marden die Farbe

drawn underneath suggests that the round objects could be breasts. A woman sunbathing appears before our eyes. Simultaneously, a brown streak above the "breasts" suggests that the woman is levitating out of the image. Could the sunbathing woman also be Maria ascending into heaven?

"Twombly ... exemplifies the importance of the ... little things that people do compared to a much larger world of all human activities,"[18] as Fairfield Porter observes. The paintings essentially demonstrate the assimilation of the world through our experiences. Twombly's language of signs represents an abstraction of direct, immediate experience. His hermetic pictorial world explores our symbolically mediated human existence and thus questions the possibility of real communication.

The works by Brice Marden shown here range from the color field images to his Second Window Painting (1983) and Untitled #1 (1986). The two latter paintings illustrate the complete break in his art that was inspired by glass painting and the influence of Far Eastern calligraphy and poetry.

In Starter (1971), For Hera (1977), and Elements I (1981-82), Marden uses paint as an opaque covering. The opacity of the painted surface is strengthened by

opak deckend auf. Die Undurchdringlichkeit der Farboberfläche wird dadurch verstärkt, dass der Künstler von 1966-81 die Farbpigmente mit Bienenwachs und Terpentinöl vermischt und so eine Farbhülle schafft, die undurchdringlich wirkt und ein eigenes Licht zu enthalten scheint. In diesen Werken ist jede Farbe auf eine eigene Leinwand aufgetragen, die in der Hängung zusammengesetzt werden. Marden experimentiert mit der Zusammenstellung der einzelnen Teile. Anders als Barnett Newman, der seine Farbfelder mit vertikalen Strichen unterbricht oder Frank Stella, der die Farbbahnen mit weissen Rändern versieht, stossen die Farben bei Marden direkt aufeinander. Es stellt sich kein Raumgefühl, keine Tiefe ein, auch offenbart die Farbbehandlung keine Handschrift. Die Kraft dieser Bilder kommt aus der Farbmaterie und dem Zusammenspiel der Farben.

Während die Farbfelder in *Starter* horizontal angeordnet sind, mit der dunkelsten Farbe unten, so ist in dem grossformatigen *For Hera* die Anordnung vertikal mit der dunkelsten Farbe, dem Blau-Schwarz in der Mitte, flankiert von tiefem Rot. Titel und Komposition spielen auf Hera, die Gefährtin des Zeus an. In *Elements I* kombiniert Marden vertikale Farbfelder mit einem horizontalen, das das Bild nach oben hin abschliesst. Marden erkundet die Kraft der Farben einzeln und im Zusammenspiel. "Painting creates a space on a wall. That space is the expression of the vision of the painter. The painter strives to make his expression explicit because he wants to affect man. By so doing he works

the fact that, from 1966-81, the artist mixed his paint with beeswax and turpentine, creating a coat of paint that seemed to be impenetrable and to contain its own light. In these works, there is one color to a canvas. The canvases are then placed together when hung. Marden experimented with the assembly of the individual panels. Unlike Barnett Newman, who broke up fields of color with vertical stripes, or Frank Stella, who added white stripes to his color fields, Marden's colors are directly adjoining. There is no feeling of space, no feeling of depth. The use of color reveals no signature. The strength and power of these paintings come from the substance and the play of the colors.

While the color fields in Starter *are horizontally arranged, with the darkest colors at the bottom, the arrangement is vertical in the large-format* For Hera. *The darkest color, a blue-black, is in the middle, flanked by a dark red. The title and composition allude to Hera, the consort of Zeus. In* Elements I, *Marden combines vertical panels of color with a horizontal one across the top. He explores the strength and power of both single and combined colors. "Painting creates a space on a wall. That space is the expression of the vision of the painter. The painter strives to make his expression explicit because he wants to affect man. By so doing he works to keep man's spirit alive."[19] The observer is drawn*

to keep man's spirit alive."[19] Der Betrachter wird in das Kraftfeld der einzelnen Farbtafeln und ihr Zusammenspiel hineingezogen. Die Grösse macht es unmöglich, sich ausserhalb zu halten.

Second Window Painting (1983) steht in Verbindung mit Entwürfen für die Glasfenster des Basler Münsters, ein Projekt, das nie ausgeführt wurde. Die fünf Farbpanele werden von diagonalen und horizontalen farbigen Strichen durchzogen, die Richtung, Räumlichkeit und Bewegung in Mardens Bildwelt einführen. Zwar sind die Linien geometrisch, sie haben aber dadurch, dass die Farbe jeweils zu einer Seite verwischt scheint, eine Lebendigkeit und Sensibilität bekommen, die in Mardens Kunst neu ist.

In *Untitled #1* (1986) ist die Lebendigkeit noch weiter vorangetrieben. Waren in *Second Window Painting* die Striche als Geraden doch noch konstruiert, geht Marden hier zu einer gestischen Pinselschrift über, die aller Geometrie entledigt ist und sich aus der monochromen Abstraktion befreit. Die Komposition basiert auf drei vertikalen Doppelreihen, die an Doppelhelixketten der DNA-Moleküle erinnern. Aus gelben, braunen, schwarzen, blauen und weissen Linien, die sich in einem grün-grauen Farbraum durchdringen und miteinander verwoben sind, schafft Marden eine organische Gitterstruktur. In diesem Bildgewebe können alle Teile voneinander unterschieden werden, und doch hängen sie alle voneinander ab. Mardens Gemälde wird zu einem lebendigen, durchlässigen Organismus, in dem sich alle Elemente in einem dynamischen Gleichgewicht befinden und pulsieren.

into the energetic field of the individual colors and their arrangement. The large format makes it impossible to remain outside the image.

The Second Window Painting *(1983) arose out of designs made by the artist for the glass windows of the cathedral in Basel, a project that was never realized. The five panels of color are crossed with diagonal and horizontal bars, introducing direction, space, and movement into Marden's pictorial world. The lines are geometrical but frayed along one edge, lending the painting a liveliness and sensitivity that is something new in Marden's art.*

In Untitled #1 *(1986) this liveliness increases. While the lines in* Second Window Painting *are still geometrical, Marden now makes use of a gestural brushstroke with no vestiges of geometry or monochrome abstraction. The composition is based on three vertical double rows of brown and yellow. These remind one of the double helix chains of DNA molecules. Marden creates an organic, interwoven latticework of yellow, brown, black, blue, and white lines, penetrating a green-gray field of color. In this pictorial fabric, all parts can be differentiated from each other, yet they are all interdependent. Marden's painting becomes a living, permeable organism of dynamically balanced, pulsating elements.*

Marden erzielt in der Malerei ab 1986 eine neue, vielschichtige Sensibilität. Wie bei Twombly wird eine gestische Handschrift sichtbar, in der das Ego jedoch weiter zurücktritt als bei diesem.

Ross Bleckners Gemälde oszillieren zwischen Abstraktion und Figuration, wobei dem Licht eine wesentliche Rolle zukommt. Seine Bilder sehen auf den ersten Blick schön aus, auf den zweiten Blick offenbaren sie, dass der schöne Schein trügt, und die Schönheit von Krankheit, fremden Mächten und von Tod infiziert ist.

In *Two Artists* (1981) wird der dunkle, vergitterte Bildraum von zwei kreisförmigen, im Bildraum schwebenden Scheiben beherrscht, die vom Betrachter aus gesehen jenseits des Gitters einsam am "Firmament" stehen. Helles, klares Licht scheint wie eine dynamische Kraft aus ihnen herauszuströmen. Es liegt nahe, die weissen Scheiben als die zwei im Titel genannten Künstler zu sehen. Sie erscheinen als Monde, je auf ihrer einsamen Umlaufbahn hoch über dem Boden schwebend, dies aber in einem Klaustrophobie erzeugenden Kosmos von Einschränkung und Begrenzung, der ihr Potential nicht zur Entfaltung kommen lässt.

Wie bei Gerhard Richter haben auch bei Bleckner viele Motive ihren Ausgangspunkt in Zeitungsbildern oder Fotos, die der Künstler sammelt und verfremdet, so wie in *Interior (With White Dots)* von 1985, das den Blick in die Saalfolge eines Schlosses oder Museums eröffnet. Auffallend ist das gleissende, "überna-

After 1986, Marden achieves a new, multilayered sensibility in painting. As in Twombly's work, a gestural handwriting becomes visible. In this handwriting, however, the ego is more reticent than in the paintings by Twombly.

Ross Bleckner's images oscillate between abstraction and figuration; light plays a significant role. At first glance, one is struck by the beauty of his paintings. A second glance reveals that the beautiful surface deceives, and that sickness, strange powers, and death infect this beauty.

In Two Artists *(1981), the dark, barred space is dominated by two round, floating discs. From the observer's perspective, these discs are on the far side of the bars, hanging isolated in the "firmament." Bright, clear light seems to flow from them, like dynamic energy. The white discs might be seen as the two artists in the title. They appear to be moons, floating along in their own solitary orbit, high over the ground, but unable to unfold their potential since they exist in a claustrophobic cosmos of restrictions and limitations.*

As in Gerhard Richter's work, many motifs in Bleckner's art are drawn from newspaper images or photographs that the artist collects. Interior (With White Dots) *of 1985 opens onto a series of rooms in a castle or museum. They are flooded with glistening, "supernatural" light that is re-*

türliche" Licht, in dem die Säle erstrahlen und das vom spiegelblanken Boden reflektiert wird. Dieses Licht kommt nur scheinbar von einem flämischen Deckenleuchter oder fällt von rechts durch die Fenster herein. In Bleckners Lichtraum ergiesst sich von oben ein mächtiger, dunkler und bedrohlicher Schatten wie ein vernichtender Wirbelwind, der im Handumdrehen das Licht in Dunkelheit verwandeln kann.

In *8,122+ As of January 1986* erhellen "künstliche" Lichtkugeln den in rotes Licht getauchten Bildraum. Ein selbstleuchtendes Gefäss, ein Zwitter zwischen Pokal und Urne, sowie die weisse, darüber schwebende Rose lassen an Tod denken. Die ins Bild eingeschriebenen Ziffern *8.122+* bezeichnen die im Steigen begriffene Anzahl der in New York bis Januar 1986 an Aids Verstorbenen. Bleckner ist einer der ersten Künstler, die zu der sich anfangs der 80er Jahre ausbreitenden Aids-Epidemie Stellung nehmen und in ihren Bildern Trauerarbeit leisten.

Circle of Us (1987) ist mit Bleckners frühen abstrakten Streifenbildern, die sich auf die Op-Art beziehen, verwandt. Bei näherem Hinsehen wird man fünf Kolibris gewahr. Der auf den ersten Blick schöne Schein des Gemäldes schlägt um, und die vertikalen Linien werden zu Gitterstäben, zu einem Gefängnis, das den Vögeln den Weg nach draussen versperrt.

Auch in *Architecture of the Sky* (1989) nimmt Bleckner die Metapher des Eingeschlossenseins ein weiteres Mal auf. Er konstruiert ein Himmelsgewölbe als abgeschlossenen Innenraum, der aussieht wie die Kuppel des Panthe-

flected in the highly polished floors. This light only seems to come from a Flemish chandelier or through the windows on the right. Into this space of light, a powerful, dark and menacing shadow swirls down from above like a devastating tornado that threatens to transform light into darkness.

In 8,122+ As of January 1986, "artificial" balls of light illuminate the pictorial space immersed in red light. A vessel lit from within, portraying a cross between a trophy cup and an urn, as well as a white rose floating above remind one of death. The numerals written into the image, 8,122+, represent the growing number of AIDS victims in New York up until January 1986. Bleckner is one of the first artists who took an artistic position at the beginning of the eighties toward the spreading AIDS epidemic, carrying out a process of mourning in his paintings.

Circle of Us *(1987) shows an affinity with Bleckner's early abstract stripe paintings that are related to Op Art. A closer look reveals five humming birds. The beautiful first impression of the painting suddenly changes; the vertical lines become prison bars, blocking the way out for the birds.*

In Architecture of the Sky *(1989), Bleckner once again takes up the metaphor of imprisonment. He constructs a heavenly vault as a closed interior that looks like the dome of the Pantheon from the inside.*

ons von innen. Wie schon in *Two Artists* ist aus diesem klaustrophobischen Himmelsraum kein Entweichen möglich. Selbst die Sterne kleben an der Innenwand wie gefangene Seelen.

Bleckners *Overexpression* (1998) gewährt Einblick in einen Mikrokosmos, in die Welt der Zellen, die hier riesenhaft vergrössert ist. Es ist eine faszinierend schöne, aber auch bedrohliche Welt. War der Bildraum in *Architecture of the Sky* begrenzt, so hebt die wuchernde Natur hier alle Begrenzungen auf, breitet sich in alle Richtungen aus und hat als unkontrollierbare Macht die Herrschaft ergriffen.

Bei aller Unterschiedlichkeit in Temperament und Verwendung des Mediums Malerei ist den drei Künstlern das Bestreben gemeinsam, mit der Malerei eine rein faktische, physische Dimension zu überschreiten und eine Geistigkeit zum Vorschein zu bringen. Sie alle erstreben mit ihrer Malerei die Wirklichkeit des Lebens hier und jetzt zu durchdringen und eine Essenz sichtbar werden zu lassen. Twomblys Bilder zeugen davon, dass in der zweiten Hälfte des 20. Jahrhunderts die Wirklichkeit nicht mehr durch die grosse Geste oder allgemeingültige Systeme beschrieben werden kann. Er lotet persönliche Erfahrungen vor dem Hintergrund seiner Faszination für die klassischen Kulturen aus, er verbindet die Vergangenheit der mediterranen Kultur mit der Gegenwart des erlebenden künstlerischen Subjekts, das Zeitlose und Universelle mit dem Hier und Jetzt. Die Überführung in eine persönliche Zeichensprache

As in Two Artists, *there is no exit from this claustrophobic heavenly space. Even the stars stick to the inner walls as if they were imprisoned souls.*

Bleckner's Overexpression *(1998) affords a look into a microcosm, into a world of cells that is here enormously magnified. It is a fascinating, beautiful, but also threatening world. While the space in* Architecture of the Sky *is delimited, rampant nature has now abolished all borders, spread in all directions, and inexorably seized control.*

Despite all the differences in temperament and the use of the medium, the three artists have a common goal: to use painting in order to transcend what is purely factual and physical, and make visible a certain spirituality. Twombly, as well as Marden and Bleckner, strive with their paintings to penetrate the reality of life here and now, to make an essence discernible. Twombly's paintings are testimonies to the fact that in the second half of the 20th century, the grand gesture or generally valid systems can no longer describe reality. Against the backdrop of his fascination for classical cultures, he plumbs the depths of personal experience. He unites the past of Mediterranean culture with the present of the living artistic subject, the timeless and the universal with the here and now. The translation of timelessness into a personal language of

stellt einen Versuch der Kommunikation dar. In dieser Übertragung, die gleichzeitig auf die prinzipiellen Grenzen von Kommunikation hinweist, scheint eine geistige Dimension in seinem Werk auf. Während Marden seine Farbfeldbilder "Resonanzflächen für den Geist" nennt, schafft er ab Mitte der 80er Jahre organische Bildräume voll von pulsierendem Leben und Harmonie, die wie eine malerische Essenz des Geheimnisses des Lebens erscheinen. Bleckner schliesslich formuliert mit den Mitteln der Malerei eine Welt im Spannungsfeld zwischen Hoffnung und Ohnmacht. Das Licht wird in seinen Gemälden zu einer Metapher für die Vision von einer Welt, in der Harmonie waltet. Das Licht ist die geistige Kraft, die sich den dunklen Mächten entgegensetzt und über die Welt des Faktischen hinausweist. Ob die Hoffnung jedoch siegen wird, lässt Bleckner offen. Im Werk aller drei Künstler tritt Geistigkeit nicht als von oben aufgesetzte Konstruktion oder als zwingendes Prinzip auf; sie erscheint in ihrer Malerei vermittelt durch ihre je individuelle Lebenspraxis.

signs and symbols represents an attempt at communication. This attempt, which itself reveals the ultimate limitations of communication, lends a spiritual dimension to his work. While Marden calls his color field images "sounding boards for a spirit," he started, in the mid-eighties, to create organic spaces full of pulsating life and harmony that seem to embody the painterly essence of the mysteries of life. Through the means of painting, Bleckner ultimately formulated a world between hope and impotence. In his paintings, light becomes a metaphor for the vision of a world in which harmony reigns. Light is the spiritual power that pits itself against the powers of darkness and points beyond the world of facts. Bleckner leaves open the question of whether hope will ever be victorious. In the work of all three artists, spirituality does not appear as a construction handed down from above, or as a human imperative. Instead, it emerges in their art through the mediation of their lives.

Anmerkungen / Notes

1 Gerhard Richter im Gespräch mit / Gerhard Richter in conversation with Doris von Drahten (4. März 1992), in: *Kunstforum International*, Bd. 131, 1995, S. 267.

2 *A New Spirit in Painting*, London, Royal Academy of Arts, 1981.
Einige Ausstellungen zur Malerei in den 90er Jahren / Exhibitions on painting in the nineties include: *Der zerbrochene Spiegel*, Wien, Messepalast und Kunsthalle, Hamburg, Deichtorhallen, 1993-94; *Peinture: Emblèmes et références*, Bordeaux, capcMusée d'art contemporain, 1994; *Unbound: Possibilities in Painting*, London, Hayward Gallery, 1994; *Das Abenteuer der Malerei / The Adventure of Painting*, Düsseldorf, Kunstverein für die Rheinlande und Westfalen, Stuttgart, Württembergischer Kunstverein, 1995; *Positionen: Beobachtungen zum Stand der Malerei in den 90er Jahren*, Essen, Museum Folkwang, 1995; *Nuevas abstracciones*, Madrid, Museo Nacional Centro de Arte Reina Sofía, Bielefeld, Kunsthalle, Barcelona, Museu d'art contemporani, 1996.

3 *Abstraction, Gesture, Ecriture: Paintings from the Daros Collection*, contributions by Yve-Alain Bois (et al.), Zurich / Berlin / New York: Scalo, 1999.

4 Johannes Meinhardt, *Ende der Malerei und Malerei nach dem Ende der Malerei*, Stuttgart: Cantz, 1997.

5 Yve-Alain Bois, "Painting: The Task of Mourning," in: *Endgame: Reference and Simulation in Recent Painting and Sculpture*, Boston: Institute of Contemporary Art, 1986, reprinted in: Yve-Alain Bois, *Painting as Model*, Cambridge, Mass. / London: MIT Press, 1990. Die folgenden Referenzen beziehen sich auf letztere Quelle / The following references refer to the latter source.

6 Ibid., p. 230.

7 Hubert Damisch, *Fenêtre jaune cadmium*, Paris: Seuil, 1984, pp. 167ff.

8 Yve-Alain Bois, op. cit., S. 241. Das Zitat im Zitat stammt von Hubert Damisch, op. cit., S. 170. Die Theorie des Spiels zur Erklärung der Malerei heranzuziehen dient vor allem der Anschaulichkeit. Meines Erachtens sind die Analogien bei genauer Betrachtung nicht völlig stringent. Wollten wir auf diese Art etwa die Malerei der Renaissance mit derjenigen der Moderne vergleichen, hätten wir wohl Schwierigkeiten, diese lediglich als zwei *Matchs* desselben Spiels zu sehen, da sowohl die Regeln wie auch das Ziel der beiden *Matchs* doch sehr unterschiedlich sind. Ich würde anstelle von *Matchs* dann lieber von zwei verschiedenen *Disziplinen* sprechen (beispielsweise Schach und Rommé). Wie auch immer, in beiden Fällen wird *gespielt*, und wenn wir von der Malerei weiterhin als *Spiel* sprechen wollen, so ist es doch undenkbar, dass es Zeiten geben soll, zu denen nicht mehr gespielt werden sollte.
Yve-Alain Bois, op. cit., p. 241. The quotation is from Hubert Damisch, op. cit., p. 170. To use game theory as a means of explaining painting is an illustrative metaphor. On closer study, the analogy is not entirely stringent, I believe. If we attempted to compare medieval and modern painting thus, we would probably be hard put to restrict our analogy to only two *matches* in the same game since both the rules and the objectives of the two *matches* in this case are very different indeed. Instead of *match*, I would prefer to speak of *disciplines* (for example, chess and rummy). But whatever the case, playing is involved in both, and if we choose to continue speaking of painting as a *game*, then it is inconceivable to think that playing could ever be abolished altogether.

9 Yve-Alain Bois weist zurecht darauf hin, dass diese Annahme auch eine neue historische Epoche impliziert, denn das Projekt der Moderne war / ist untrennbar verknüpft mit seinen historischen Bedingungen (Fotografie, Mechanisierung etc.). Sollte das Ende erreicht sein, müssten auch diese Bedingungen abgelöst werden. "Zu behaupten, das 'Ende der Malerei' sei vollendet, heisst zu behaupten dass diese historische Situation nicht länger die unsere ist, und wer wäre naiv genug, diese Behauptung aufzustellen, wenn Reproduzierbarkeit und Fetischisierung offensichtlich alle Aspekte des Lebens durchdringen, unsere 'natürliche' Welt geworden sind?", op. cit., S. 242.
Yve-Alain Bois rightly points out that this assumption implies a new historical epoch because the project of modernism was / is inseparably linked with its histori-

cal circumstances (photography, mechanization, etc.). Had we really reached the end, then these circumstances would have to yield to change as well. "To claim that the 'end of painting' is finished is to claim that this historical situation is no longer ours, and who would be naive enough to make this claim when it appears that reproducibility and fetishization have permeated all aspects of life: have become our 'natural' world?", op. cit., p. 242.

10 Ich möchte Catherine Schelbert und Brenda Richardson für ihre kritischen Kommentare zum Titel dieser Publikation danken.
I wish to thank Catherine Schelbert and Brenda Richardson for their critical comments on the title of this publication.

11 "La Peinture est plus forte que moi, elle me fait faire ce qu'elle veut." Handschriftliche Notiz Picassos auf der dritten Umschlagseite des Skizzenbuchs MP. 1886, datiert vom 10. 2. 63 bis 21. 2. 63, abgebildet in / Handwritten note of Picasso's on the third cover page of sketchbook MP. 1886, dated 10. 2. 63 to 21. 2. 63, reproduced in: Marie-Laure Bernadac, "Picasso, 1953-1973: La peinture comme modèle," *Le dernier Picasso*, Paris: Centre Georges Pompidou, 1988, p. 19. (English edition: *Late Picasso*, London: Tate Gallery, 1988, p. 50.) Ich danke Yve-Alain Bois für den Hinweis auf dieses Zitat / I thank Yve-Alain Bois for drawing my attention to this quotation.

12 G.R. Swenson, "What is Pop Art?: Answers from 8 Painters, Part I," *Artnews*, vol. 62, November 1963, p. 60, zitiert in: Kynaston McShine, *Andy Warhol: Retrospektive*, München: Prestel, 1989, S. 452 / cited by Kynaston McShine, *Andy Warhol: A Retrospective*, New York: The Museum of Modern Art, 1989, p. 460.

13 Gerhard Richter, Text: *Schriften und Interviews*, hrsg. von Ulrich Obrist, Frankfurt M. / Leipzig: Insel Verlag, 1993, S. 92.

Gerhard Richter, *The Daily Practice of Painting: Writings and Interviews 1962-1993*, ed. by Hans-Ulrich Obrist, Cambridge, Mass.: The MIT Press, in association with the Anthony d'Offay Gallery, London, 1995, p. 100.

14 Aus Twomblys Bewerbungsschreiben für das Catherwood Foundation Fellowship, 1956, zitiert in: Kirk Varnedoe, "Inschriften in Arcadia", in: *Cy Twombly: Eine Retrospektive*, München: Schirmer / Mosel, 1994, S. 67, Anm. 99.
From Cy Twombly's application for the Catherwood Foundation Fellowship, 1956. Cited by Kirk Varnedoe, "Inscriptions in Arcadia," in: *Cy Twombly: A Retrospective*, New York: The Museum of Modern Art, 1994, p. 61, n. 99.

15 Aus einem undatierten Brief Twomblys an Leslie Cheek, Jr. (vermutlich vom Mai 1953). Ibid., S. 64, Anm. 61.
Undated letter from Cy Twombly to Leslie Cheek, Jr. (probably May 1953). Ibid., p. 58, n. 51.

16 Heiner Bastian (ed.), Cy Twombly: *Catalogue Raisonné of the Paintings, Vol. I*, München: Schirmer/ Mosel, 1992, S. 278 / p. 278.

17 Katharina Schmidt, "Weg nach Arkadien: Gedanken zu Mythos und Bild in der Malerei von Cy Twombly", in: *Cy Twombly*, Baden-Baden: Staatliche Kunsthalle, 1984, S. 61.
Katharina Schmidt, "The Way to Arcadia: Thoughts on Myth and Image Inside Twombly's Painting," in: *Cy Twombly*, Houston, Texas: The Menil Collection, 1999, pp. 11-12.

18 Zitiert in / Cited by Yve-Alain Bois, "'Der Liebe Gott steckt im Detail': Reading Twombly," in: Yve-Alain Bois (et al.), *Abstraction, Gesture, Ecriture: Paintings from the Daros Collection*, Zurich / Berlin / New York: Scalo, 1999, p. 61.

19 Brice Marden, 1975, in: *Brice Marden: Paintings, Drawings and Prints 1975-1980*, London: Whitechapel Art Gallery, 1981, S. 54 / p. 54.

In the Power of Painting

Andy Warhol

Sigmar Polke

Gerhard Richter

Cy Twombly

Brice Marden

Ross Bleckner

Andy Warhol

Michael Lüthy

Warhols Kunst bestellt ein bildnerisches Feld jenseits der Malerei. Vor dem 1960 umgesetzten Entschluss, Künstler zu werden, arbeitete Warhol äusserst erfolgreich als Werbegrafiker. Während sein diesbezüglicher Erfolg auf einem betont intimen und handwerklichen Stil basierte, beruht sein Erfolg als Künstler genau entgegengesetzt auf einem entpersönlichten, die individuelle Handschrift meidenden Konzept. "I've made a career out of being the right thing in the wrong space and the wrong thing in the right space", so wird Warhol später beschreiben, wie er die Erwartungen jeweils unterläuft.

Eine unübersehbare Themenfülle kennzeichnet das Werk, das im Laufe seiner Entwicklung eine enzyklopädische Dimension gewinnt. Mit der thematischen Vielfalt kontrastiert jedoch eine formale Gleichförmigkeit. Warhol entwickelt eine Bildschablone, die auf alles zu passen scheint und zugleich alles zu einem "Warhol" zu machen versteht. Das Bindeglied zwischen den universalen Inhalten und ihrer uniformen Darstellung liegt darin, dass Warhol jeweils nicht von den Dingen, sondern von deren Bild ausgeht: von Fotografien, Diagrammen oder Werbezeichnungen. So handelt seine

Warhol's art occupies an artistic area beyond painting. Before making his decision to become an artist in 1960, Warhol worked very successfully as a commercial graphic designer. While his success in this field was based on a notably intimate and craftsmanlike style, his success as an artist rests on its opposite: a depersonalized concept avoiding any kind of individual handwriting. "I've made a career out of being the right thing in the wrong space and the wrong thing in the right space," was Warhol's later description of the way in which he always subverted expectations.

A wide variety of subjects is characteristic of Warhol's work, which assumed encyclopedic dimensions in the course of his development. However, its thematic diversity contrasts with a certain formal uniformity. Warhol developed a pictorial stereotype that seemed adaptable to everything, and at the same time could make a "Warhol" of any subject. The link between the universal content of his work and its uniformity of depiction lies in the fact that Warhol always set out not from objects

Kunst weniger von der Wirklichkeit als von deren medialer Transformation. Einem solchen technischen und medialen Weltzugang entspricht Warhols Form der Bilderzeugung, die ab 1962 durchgängig auf der seriellen Siebdrucktechnik basiert. Seine Werke entstehen dabei in der Überzeugung, dass ein Bild nicht bloss ein Abbild der Dinge, sondern vielmehr deren eigentliches "Sein" darstellt. Am deutlichsten wird dies in Warhols Beschäftigung mit dem Phänomen des Stars, dessen Wirklichkeit ganz "Bild", ganz "image" ist.

Die Komplexität von Warhols Kunst lebt vom Widerspruch: Seine Werke offenbaren die Kluft zwischen der Wirklichkeit und ihrer bildlichen Reproduktion und lassen die Differenz zugleich schwinden – bis zum Punkt, wo Wirklichkeit und Bild verschmelzen. Präsenz und Absenz schlagen ineinander um, das Vermittelte erscheint unvermittelt und das Unvermittelte unendlich vermittelt. "I don't know where the artificial stops and the real starts", gesteht Warhol und bringt damit eine künstlerisch wie auch in seiner persönlichen Erscheinungsweise konsequent umgesetzte Ungewissheit auf den Punkt.

themselves but from their images: from photographs, diagrams, or commercial graphics. In this way his art deals less with reality than with its transformation by the media. His creative procedure, which from 1962 was generally based on the serial screen-printing technique, corresponded to this technical and media-based approach. His works were produced in the conviction that a picture was not simply a copy of something, but instead represents its real essence. This is most obvious in Warhol's concentration on the phenomenon of the film star whose reality is all "image."

The complexity of Warhol's art feeds on contradiction: his works reveal the gulf between reality and its pictorial reproduction, at the same time blurring the difference to the point where reality and image become one. Presence and absence merge with each other; what has been filtered seems to be unfiltered, and what has been unfiltered seems endlessly filtered. "I don't know where the artificial stops and the real starts," Warhol confessed, pinpointing an uncertainty that he consistently expressed both artistically and in the conduct of his personal life.

"Ich liebe Amerika ... Mein Bild [Storm Door, 1960] ist eine Aufstellung der Symbole der erbarmungslosen, unpersönlichen Produkte und schamlos materialistischen Objekte, auf denen Amerika heute aufgebaut ist. Es ist eine Projektion von allem, was man kaufen und verkaufen kann, der praktischen, aber unbeständigen Symbole, die uns aufrechterhalten."

Andy Warhol, 1960

"I adore America ... My image [Storm Door, 1960] is a statement of the symbol of the harsh, impersonal products and brash materialistic objects on which America is built today. It is a projection of everything that can be bought and sold, the practical but impermanent symbols that sustain us."

Andy Warhol, 1960

Andy Warhol
Storm Door, 1960
Acrylfarbe auf Leinwand, 117 x 107 cm
Synthetic polymer paint on canvas
46 x 42⅛ inches

Andy Warhol
Where Is Your Rupture?, c. 1960
Acrylfarbe auf Leinwand
137.5 x 177.5 cm
Synthetic polymer paint on canvas
54 1/4 x 69 7/8 inches

"Ich will nicht, dass es im Wesentlichen das-
selbe ist – ich will, dass es genau dasselbe ist.
Denn je mehr man genau dasselbe Ding be-
trachtet, umsomehr schwindet die Bedeutung,
umso besser und leerer fühlt man sich."

Andy Warhol, 1980

"I don't want it to be essentially the same—
I want it to be exactly the same. Because the
more you look at the same exact thing, the
more the meaning goes away, and the better
and emptier you feel."

Andy Warhol, 1980

56

Andy Warhol
Typewriter, 1961
Acrylfarbe und Kreide auf
Leinwand, 138 x 177.7 cm
Synthetic polymer paint and
crayon on canvas, 54 3/8 x 70 inches

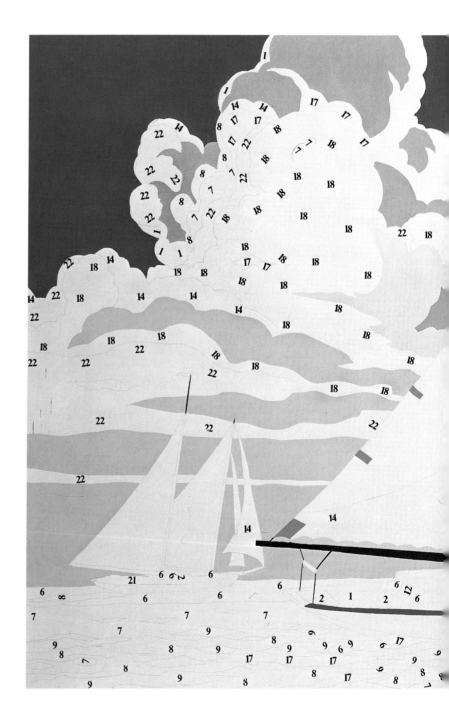

Andy Warhol
Do-It-Yourself (Sailing Boats), 1962
Acrylfarbe, Abreibebuchstaben und Bleistift
auf Leinwand, 182.9 x 254 cm
Synthetic polymer paint, Prestype, and
pencil on canvas, 72 x 100 inches

58

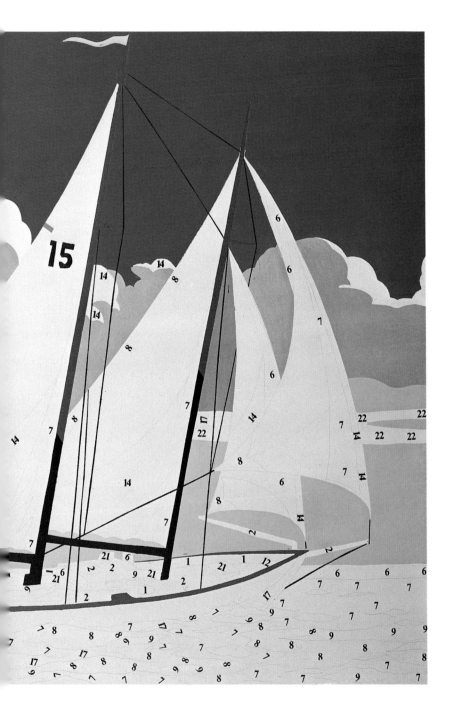

"Ich habe immer noch Interesse an Menschen,
aber es wäre viel einfacher, wenn man sich
überhaupt nicht um sie kümmerte. Ich will nicht
zu nahe kommen; ich mag es nicht, Dinge zu
berühren, deshalb ist mein Werk so weit
von mir entfernt."

Andy Warhol

*"I still care about people but it would be so
much easier not to care. I don't want to get
too close; I don't like to touch things, that's
why my work is so distant from myself."*

Andy Warhol

Andy Warhol
Race Riot, 1963
Siebdruckfarbe und Acrylfarbe
auf Leinwand, 307 x 210 cm
Silkscreen ink and synthetic polymer
paint on canvas, 121½ x 82⅝ inches

60

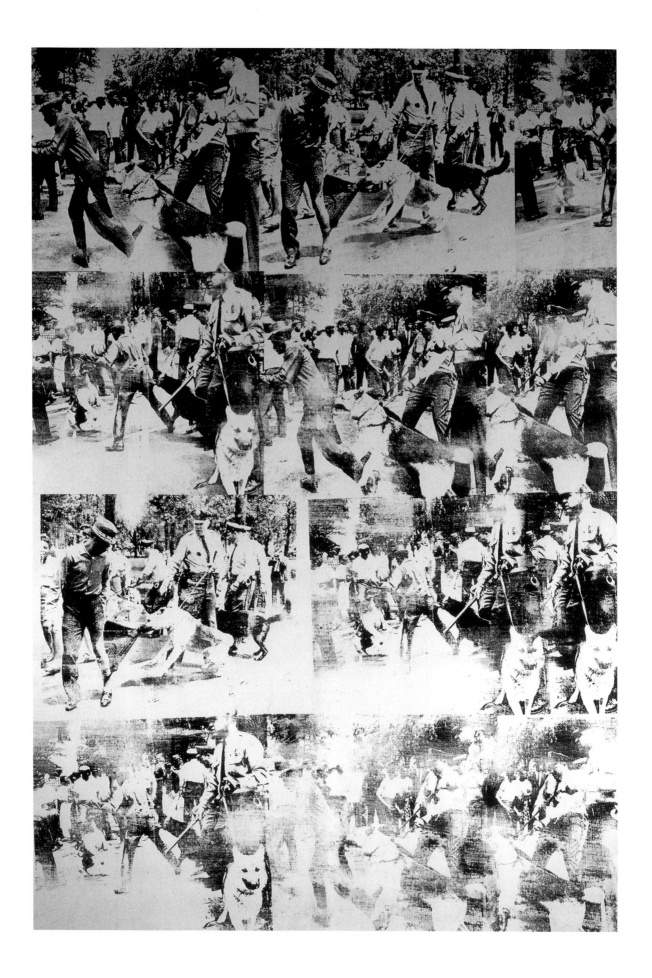

Andy Warhol
Blue Liz as Cleopatra, 1963
Siebdruckfarbe und Acrylfarbe
auf Leinwand, 209 x 165 cm
Silkscreen ink and synthetic polymer
paint on canvas, 82¼ x 65 inches

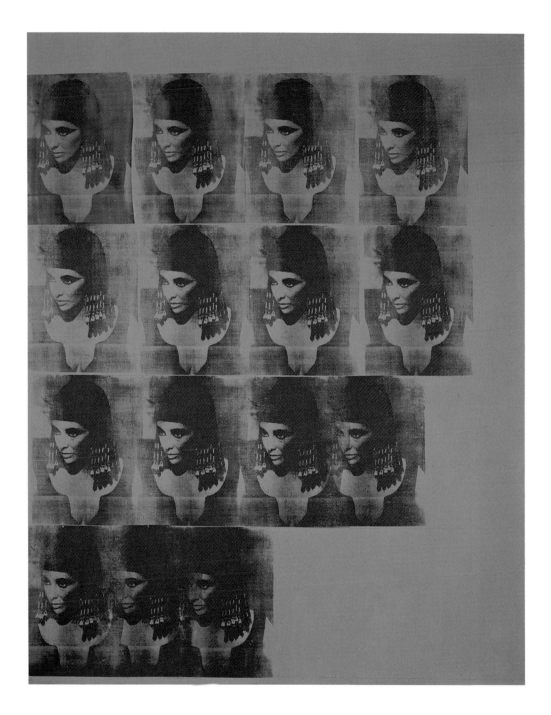

"Der Abstrakte Expressionismus ist bereits zur
Institution geworden, und dann haben Jasper
Johns, Bob Rauschenberg und andere Ende der
50er Jahre begonnen, die Kunst von der Ab-
straktion und dem introspektiven Zeug zurück-
zubringen. Dann nahm die Popkunst das
Innere und kehrte es nach aussen, nahm das
Äussere und kehrte es nach innen."

<div align="right">Andy Warhol, 1980</div>

"*Abstract Expressionism had already become
an institution, and then, in the last part of
the fifties, Jasper Johns und Bob Rauschen-
berg and others had begun to bring art back
from abstraction and introspective stuff.
Then Pop Art took the inside and put it
outside, took the outside and put it inside.*"

<div align="right">*Andy Warhol, 1980*</div>

<div align="right">Andy Warhol

Mona Lisa, 1963

Siebdruckfarbe und Acrylfarbe

auf Leinwand, 320 x 208.5 cm

Silkscreen ink and synthetic polymer

paint on canvas, 125 3/4 x 82 1/8 inches</div>

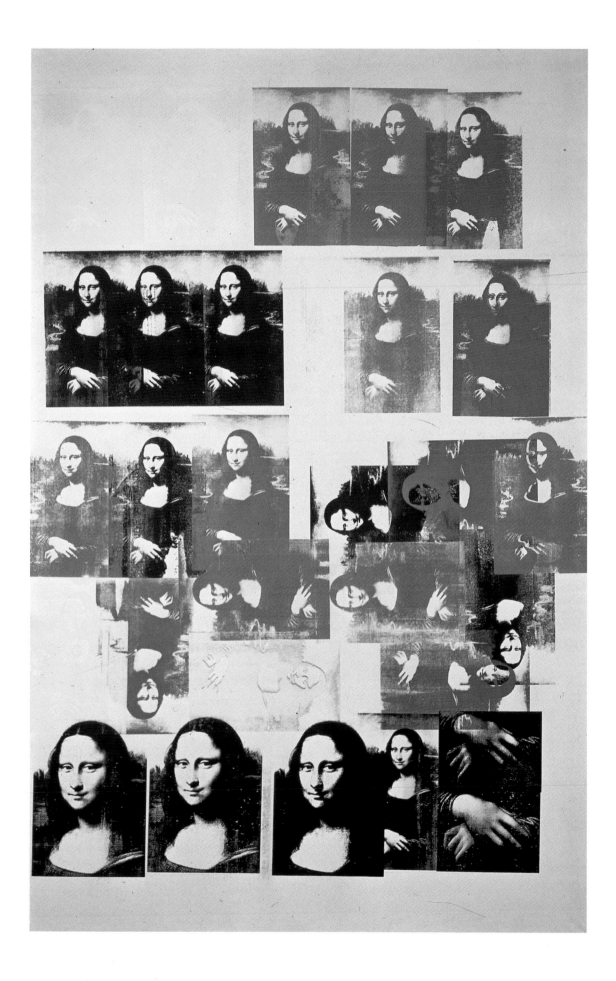

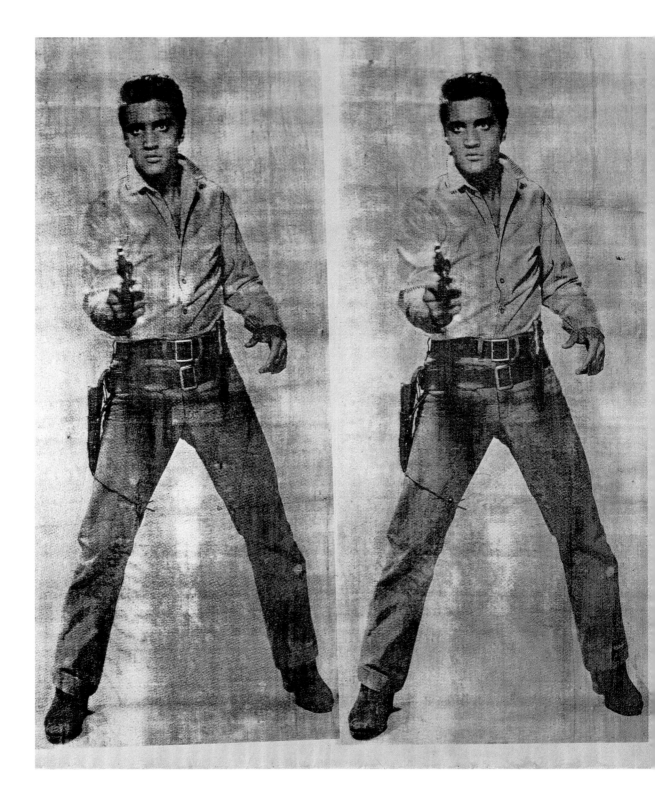

Andy Warhol
Elvis (4 times), 1963
Siebdruckfarbe und Aluminiumfarbe
auf Leinwand, 212 x 382 cm
Silkscreen ink and aluminum paint
on canvas, 83 ½ x 150 ½ inches

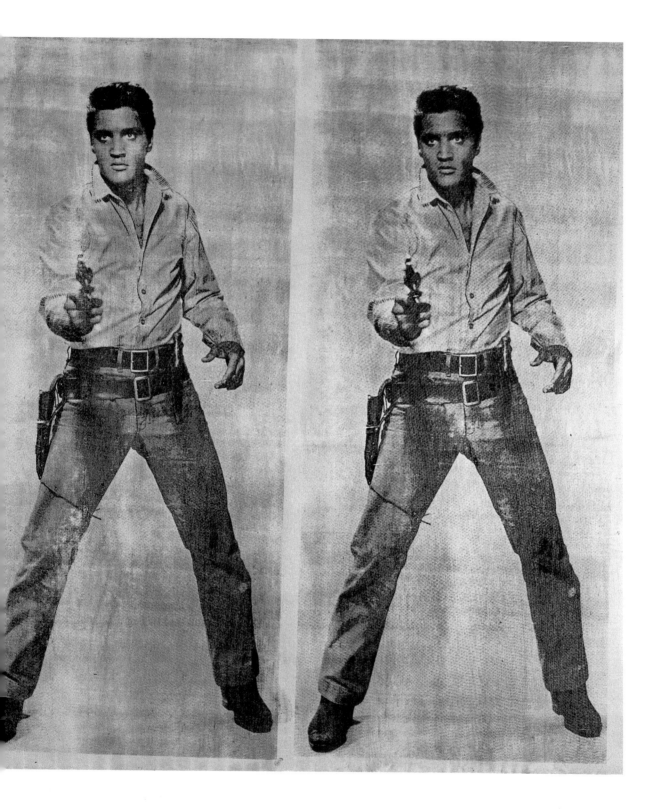

Sigmar Polke

Martin Hentschel

Das Wirtschaftswunder hat sich bereits konsolidiert, als Sigmar Polke die neudeutsche Gemütlichkeit malerisch aufs Korn nimmt. Nierentisch und Palme, Reiherpärchen und Negerplastik: Die Topoi kleinbürgerlicher Sehnsüchte fügen sich in seiner Bilderwelt zu dissonanter Eintracht. Mit Scharfsinn und Ironie spürt er die ideologischen Fallen der Konsumkultur auf. Das ist das Credo des "Kapitalistischen Realismus", der auch vor der Kunst selbst nicht haltmacht. Die abstrakte Malerei, die sich in den späten 50er Jahren zu einer Weltsprache aufschwang, wird jetzt von Polke mitleidlos zur leeren Geste gestempelt und mit Versatzstücken von Kitsch kontaminiert.

Er erfindet zwei Methoden der Dekonstruktion: Das Rasterbild und die Malerei auf industriell bedruckten Textilien. Im Rasterbild tritt die Welt, wie sie die Printmedien darbieten, als blosses Muster auf; und der Künstler zeigt, dass dieses Muster zerlegt und wieder neu zusammengesetzt werden kann. Auch die Stoffmuster, deren er sich bedient, durchlaufen solche Metamorphosen. Alles wird in alles verwandelbar, und gerade, wenn es sich gegen die geltenden Geschmacksmuster kehrt.

Germany's economic comeback has already been consolidated by the time Sigmar Polke begins to send up neo-German gemütlichkeit in his paintings. Kidney-shaped coffee tables and palms, pairs of herons and African sculpture: Polke weaves the topoi of petit bourgeois longings into a pictorial fabric of dissonant harmony. With discerning irony, he exposes the ideological pitfalls of consumer culture with his credo of a "Capitalist Realism" that even infiltrates art. Relentlessly, he brands the abstract painting of the fifties, which soon becomes a world language, as an empty gesture, contaminated with set pieces of kitsch.

He invents two methods of deconstruction: benday dot pictures and painting on patterned textiles of industrial manufacture. In the screen paintings, the world of the printed media appears as a mere pattern, and Polke effectively demonstrates how this pattern can be taken apart and reassembled. The pre-printed fabrics that he exploits are similarly subject to metamorphosis. Everything can be transformed into everything else, especially when the trans-

In der Kombinatorik von Motiven und Themen entfaltet Polke ein geradezu enzyklopädisches Interesse, und dieses Interesse dehnt sich zu Beginn der 80er Jahre auf die Bildfarbe aus. Mit anarchischer Neugier gewährt er Tinkturen und Lacken, tellurischen und extraterrestrischen Materialien Wege ins Bild. Er entwickelt eine Alchemie der Farben, die wie die Natur zu unvorhersehbaren Mutationen fähig ist. Malereien, die auf Wärme und Feuchtigkeit reagieren, gehören zu den Höhepunkten dieser experimentellen Kunst. Hatte Polke schon in den Stoffbildern den Bildträger selbst als Bildmotiv stimuliert, so macht er ihn in den Transparentbildern zum eigentlichen Untersuchungsgegenstand. Der Bildträger, oft beidseitig bemalt, wird zum Werkzeug multipler Perspektiven, während sich das Sichtbare von ihm ablöst. Mit seinen irisierenden und durchscheinenden Bildern ohne einheitlichen Brennpunkt der 90er Jahre entwickelt Polke für die Malerei einen neuen Raumbegriff, der nicht mehr mimetisch ist.

formation flies in the face of prevailing conventions of taste.

In the combination of motifs and themes, Polke shows a near encyclopedic interest; it is expanded to include pictorial color in the early eighties. With anarchistic curiosity, he carves paths in his pictures for tinctures and lacquers, for telluric and extraterrestrial materials. He works out an alchemy of pigments, capable, like nature, of unanticipated mutation. Paintings that react to warmth and humidity are among the highlights of this experimental art. Polke was already inspired by the support itself as pictorial motif in his fabric paintings, but in the "transparent pictures" it becomes the actual subject of his investigations. The support, often painted on both sides, becomes the instrument of multiple perspectives while the visible is removed altogether. With his iridescent, diaphanous, and polyfocal pictures of the nineties, Polke develops a new concept of space in painting that is no longer mimetic.

Sigmar Polke
Palmenbild mit Gitter, 1967
Öl auf Leinwand und Acrylfarbe
auf Holzgitter, 211 x 195.5 cm
Oil on canvas and acrylic on wooden
trellis, 83¾ x 76½ inches

Sigmar Polke
Reiherbild II, 1968
Dispersion auf Flanell, 190 x 150 cm
Synthetic resin on flannel
74³/₄ x 59 inches

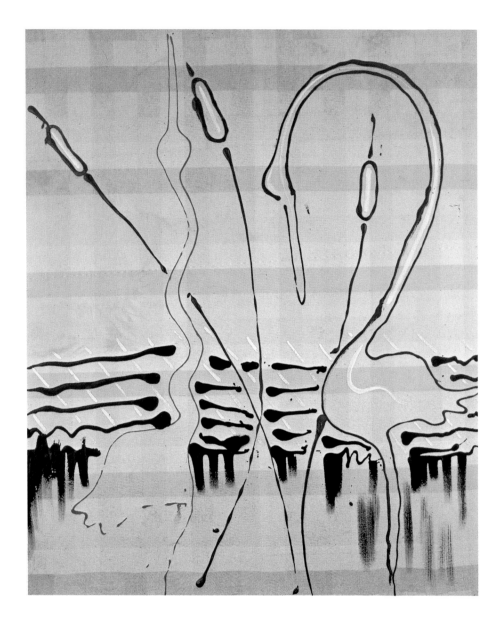

Sigmar Polke
Wolldeckenbild mit weissen Quadraten, 1968
Dispersion auf Wolldecke, 150 x 126 cm
Synthetic resin on woolen blanket
59 x 49 ½ inches

"Die Rasterbilder sind ein Reproduktions-
problem, ein Problem von Druckfehler und
Verselbständigung bis hin zur Loslösung vom
Vorbild und dem, was hinter dem Vorbild erst
anfängt und etwas eigenes sein will und muss.
Und wann das eintritt. Und wann du bereit
bist, das eine zu sehen als ein Vorbild und
das andere als eine eigene Sache."

<div align="right">Sigmar Polke, 1984</div>

*"The dotscreen pictures deal with the problem
of reproduction, the problem of printing
mistakes and going off in another direction
until there is no connection anymore
between the subject and its reproduction.
It's what happens behind the subject. Some-
thing independant, so that you are prepared
to see the one as a subject and the other
thing as in its own right."*

<div align="right">*Sigmar Polke, 1984*</div>

<div align="right">Sigmar Polke
What can you hear through an ear of grain?, 1976
Dispersion auf Leinwand, 110 x 110 cm
Synthetic resin on canvas, 43 ¼ x 43 ¼ inches</div>

What can you hear through an **ear of grain**?

Sigmar Polke, *Burda*, 1979-82
Dispersion auf Stoff, zwei und sechs Teile
180 x ca. 300 cm insgesamt
Synthetic resin on fabric, two and six panels
70 7/8 x c. 118 inches overall

Sigmar Polke, *Paganini*, 1981-83
Dispersion auf Stoff, 223 x 504 cm
Synthetic resin on fabric, 87 3/4 x 198 1/2 inches

"Was bei der Überlagerung einhakt, ist dein Überlagerungswissen, um dann das sehen zu können: also eine Pfeife ist keine Pfeife – das sehen und verstehen können, dass also ein Bild praktisch nur da ist, den Kopf in Bewegung zu halten, mit dem, was er sowieso drin hat."

<div style="text-align:right">Sigmar Polke, 1984</div>

"What takes hold in layering is the knowledge of layers that allows you to see: in other words a pipe is not a pipe. The point is to see that, to understand that a picture is basically only what keeps your head moving with what is already in it."

<div style="text-align:right">*Sigmar Polke, 1984*</div>

<div style="text-align:right">Sigmar Polke
Lumpi hinter dem Ofen, 1983
Mischtechnik auf Stoff auf Leinwand
319 x 250.5 cm
Mixed media on fabric mounted on canvas
125 ½ x 98 ⅝ inches</div>

Gerhard Richter

Martin Hentschel

Als Gerhard Richter zu Beginn der 60er Jahre das Amateur- und Zeitungsfoto als Vorlage für seine gegenständlichen Bilder entdeckt, wirkt das für ihn wie ein Befreiungsschlag. Eine Befreiung von der politisch motivierten Malerei, zu der er in der Dresdner Akademie ausgebildet wurde, ebenso wie von der subjektzentrierten Malerei des westdeutschen Informel und Tachismus. Unter bewusster Vernachlässigung von Komposition, Stil und persönlicher Weltsicht malt er Flugzeuge, Hirsche, Könige und Sekretärinnen: Die ganze Palette dessen, was ihm in der Welt des Faktischen zufällt. Es ist der Beginn einer fortdauernden Befragung dessen, was dem Bild und der Malerei möglich ist. Dabei forciert er seine unverwechselbare Verwischtechnik bis zur Auflösung der Gegenstandsgrenzen, und er treibt den malerischen Duktus bis an den Punkt, an dem sich Motiv und Farbsubstanz als alternierende Objekte des Sehens zeigen.

Die fundamentale Skepsis, zu einer wie immer gearteten, gültigen Erkenntnis der Wirklichkeit gelangen zu können, findet in den "Grauen Bildern" von 1974/75 einen radikalen Niederschlag. Diese Arbeiten markieren zugleich einen Wendepunkt in seiner Malerei. Denn bei allen

When Gerhard Richter discovers amateur and newspaper photographs for his figurative pictures at the beginning of the sixties, a sense of liberation overwhelms him: liberation from the politically motivated painting, for which he has been trained at the academy in Dresden, and also from the subject-oriented painting of West German Art Informel and Tachisme. Intentionally ignoring composition, style, and personal worldview, he paints airplanes, stags, kings, and secretaries: the entire palette of whatever crosses his path in the world of factuality. It is the beginning of an ongoing inquiry into the basic potential of the picture and painting. In the process, Richter pushes his inimitable technique of blurring to the point of dissolving the boundaries of the object, and his painterly gesture to the point of making the motif and the paint indistinguishable as alternating objects of seeing.

The profound skepticism about ever attaining valid insight—of any kind—into reality finds radical expression in the "Gray Paintings" of 1974/75. These works also mark a turning point in his œuvre. For, de-

Aporien bewahrt sich Richter doch den Glauben, aus dem Prozess des Malens selbst könne etwas Kluges und Unvordenkliches erwachsen, wenn man ihn nur geschehen lasse, anstatt ihn zu kreieren. In der Dialektik von Komposition und Dekomposition erarbeitet er ein breit angelegtes Œuvre abstrakter Bilder. Sie vergegenwärtigen das Unbegreifliche in der Form fiktiver Modelle: Eine Möglichkeit der Utopie in einer Welt verdinglichter Interessen. Nicht von ungefähr greift Richter parallel immer wieder auf die Landschaft als Sujet seiner Fotomalerei zurück. Das geschieht nicht so sehr aus Gründen der Nostalgie. Vielmehr liegt für ihn gerade im ephemeren Naturausschnitt, der aus dem Erinnerungsfoto in die Malerei übersetzt wird, das Äquivalent zum abstrakten Bild, welches wie die Landschaft jede Art von Totalität notwendigerweise verweigert.

spite all aporias, Richter still believes that the process of painting is capable of spawning something intelligent and primal if it is given free rein rather than conscious creative guidance. Within the dialectics of composition and decomposition, he produces a wide range of abstract pictures, representing the unfathomable in the form of fictional models: the possibility of a utopia in a world of reified interests. It is no accident that Richter keeps coming back to the subject matter of the landscape in his photopaintings. Nor is he motivated by nostalgia in so doing. Rather, the ephemeral slice of nature, translated from a photograph into painting, is in fact equivalent to the abstract picture, which, like the landscape, necessarily refuses any kind of totality.

"Ich verwische, um alles gleich zu machen, alles gleich wichtig und gleich unwichtig. Ich verwische, damit es nicht künstlerisch-handwerklich aussieht, sondern technisch, glatt und perfekt. Ich verwische, damit alle Teile etwas ineinanderrücken. Ich wische vielleicht auch das Zuviel an unwichtiger Information aus."

<div align="right">Gerhard Richter, 1964-65</div>

"I blur things to make everything equally important and equally unimportant. I blur things so that they do not look artistic or craftsmanlike but technological, smooth and perfect. I blur things to make all the parts a closer fit. Perhaps I also blur out the excess of unimportant information."

<div align="right">*Gerhard Richter, 1964-65*</div>

<div align="right">Gerhard Richter
Rokokotisch, 1964
Öl auf Leinwand, 90 x 100 cm
Oil on canvas, 35 3/8 x 39 3/8 inches</div>

Gerhard Richter
Frau mit Schirm, 1964
Öl auf Leinwand, 160 x 95 cm
Oil on canvas, 63 x 37 ⅜ inches

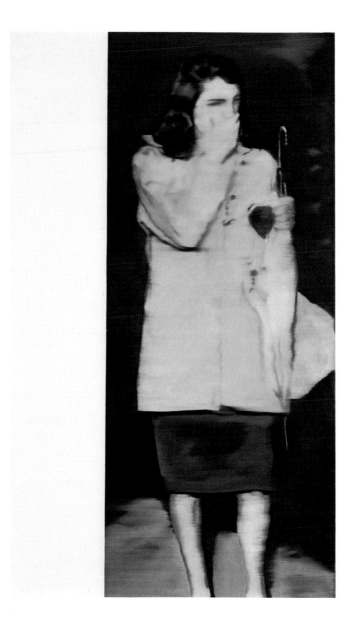

"Auf [dem] Umweg über die Malerei kann ich Fotos erhalten, die mit den üblichen Verfahren der direkten Vergrösserung nicht zustande kommen, und diese Fotos können dann doch Bilder sein."

Gerhard Richter, 1972

"The detour by way of painting gives me photographs that cannot be made by the normal technique of direct enlargement; and these photographs can be pictures."

Gerhard Richter, 1972

Gerhard Richter
Stadtbild D, 1968
Öl auf Leinwand, 200 x 200 cm
Oil on canvas, 78 3/4 x 78 3/4 inches

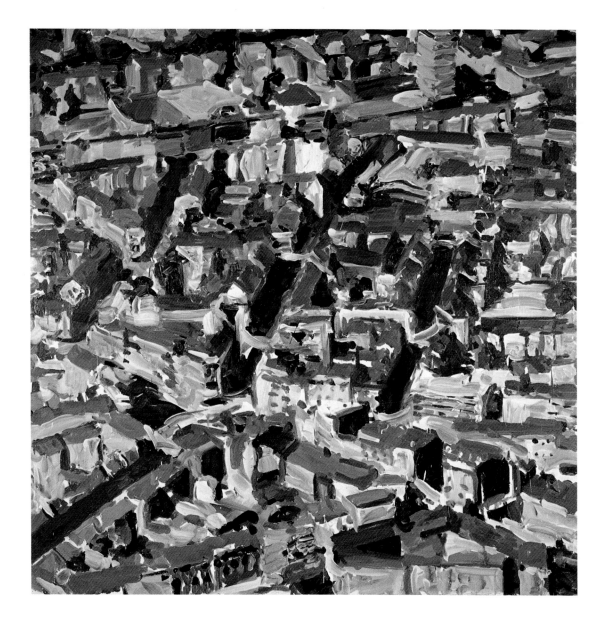

"... ich versuche doch mit einem Bild nichts
anderes, als das Unterschiedlichste und Wider-
sprüchlichste in möglichster Freiheit lebendig
und lebensfähig zusammenzubringen. Keine
Paradiese."

<div align="right">Gerhard Richter, 1986</div>

"... all that I am trying to do in each picture
is to bring together the most disparate and
mutually contradictory elements, alive and
viable, in the greatest possible freedom.
No Paradises."

<div align="right">Gerhard Richter, 1986</div>

Gerhard Richter
Feldweg, 1987
Öl auf Leinwand, 82 x 112 cm
Oil on canvas, 31¼ x 44⅛ inches

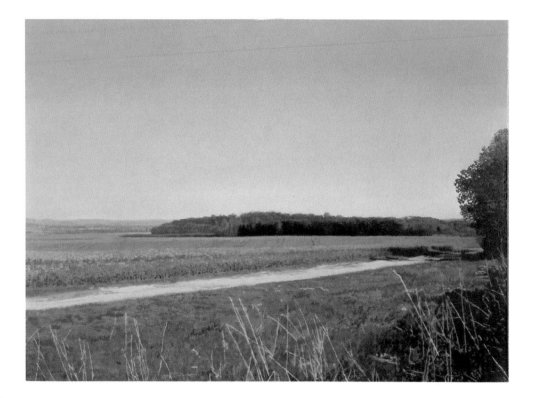

Cy Twombly

Iris Müller-Westermann

Cy Twomblys früheste Arbeiten um 1950 zeugen von der Auseinandersetzung mit dem Abstrakten Expressionismus. Zusammen mit seinem Freund Robert Rauschenberg, den er an der Art Students' League in New York kennengelernt hatte, unternimmt er 1952-53 eine erste Reise nach Europa – vornehmlich nach Italien – und nach Nordafrika. Unter dem Einfluss der mediterranen Kultur wandelt sich seine Kunst in den kommenden Jahren grundlegend.

1955 entwickelt er aus der Abstraktion eine ganz persönliche Schrift, ein spontanes Schreiben, das mit der surrealistischen *écriture automatique* verwandt ist. Twombly überzieht grosse, entweder schwarz oder mit hellen beigen Tönen grundierte Leinwände mit einem gewebeartigen Lineament aus Kreide-, Bleistift- und Farbstiftstrichen. Im Entstehungsprozess seiner Bilder verwischt, übermalt und überschreibt er bereits Geschriebenes, wobei frühere Schichten als Rudimente durchscheinend sichtbar bleiben. Eine kryptische Zeichensprache, mit der der Künstler auf subjektiv Erlebtes reagiert, ersetzt die grosse Geste. Twomblys "Schrift", die an Graffiti denken lässt, will kommunizieren und das unmittelbar Erlebte umsetzen, während sie

Twombly's earliest works, dating from the late forties and early fifties, are testimonies to his investigation of Abstract Expressionism. Together with his friend Robert Rauschenberg, whom he had met at the Art Students' League in New York, he undertook his first trip to Europe—principally to Italy—and North Africa in 1952-53. Under the influence of Mediterranean culture, his art changed significantly in the ensuing years.

In 1955, his studies in abstraction developed into a very spontaneous and personal writing, related to the Surrealist écriture automatique. *Twombly covered large canvases primed with black or light beige paint with a weave of chalk, lead, and colored pencil strokes. During the process of creation, he blurred, painted over, and wrote over things he had already written, while old layers, like rudiments, remain translucently visible. In Twombly's work the grand gesture is replaced with a cryptic language of signs that the artist used to react to subjective experiences. His "writing," reminding one of graffiti, wants to*

zugleich die Grenzen jeglicher Kommunikation vor Augen führt.

1957 siedelt Twombly nach Italien über und macht die klassische europäische Kultur zum Bezugssystem seiner Kunst. Zur selben Zeit beginnt sich in Amerika mit der Popkunst eine Gegenbewegung zum Abstrakten Expressionismus durchzusetzen, die ihren Ausgangspunkt in der Massenkultur der amerikanischen Konsumgesellschaft hat. Die Farbskala von Twomblys Kreidetönen wird ab 1959 reicher und die "Schrift", jenseits eines Alphabets, löst sich in graphische Partikel und bildliche Zeichen auf. 1960-61 tauchen neue Themen auf. Die Farbe bekommt nun eine zentrale Bedeutung, verleiht seinem Werk einen bislang unbekannten sinnlichen Reiz und ersetzt weitgehend die graphischen Zeichen.

Ab Mitte der 60er Jahre treten dann in den "grauen Bildern" mit ihren Kreidegraphismen formale Untersuchungen in den Vordergrund, die der Minimal- und Konzeptkunst nahestehen. Die letzten drei Dekaden seines Werks haben als konstantes Merkmal einen geradezu eruptiven Umgang mit der Farbe.

Vor dem Hintergrund seiner Faszination für klassische Kulturen lotet Twombly persönliche Erfahrungen aus und verbindet die Vergangenheit der mediterranen Kultur mit der Gegenwart seines eigenen künstlerischen Erlebens und damit das Zeitlose und Universelle mit dem vergänglichen Augenblick.

communicate, wants to render direct experience, while at the same time showing the limitations of communication.

In 1957, Twombly moved to Italy and made classical European culture his system of reference, while, in the United States, the reaction to Abstract Expressionism led to Pop art, which had its source in the mass culture of American consumer society. Twombly's palette of chalk tones became richer after 1959, and his "writing"—beyond any alphabet—dissolved into graphic particles and imagistic signs. In 1960-61, new themes begin to surface. Color receives a central importance and a sensual attractiveness previously unknown in his work and largely displaces the graphic signs.

In the mid-sixties, he devoted himself to formal investigations related to Minimalist and Conceptual art in his "gray paintings" with their chalk and crayon graphics, while color almost seems to have erupted in his work over the past three last decades.

Against the backdrop of his fascination for classical culture, Twombly plumbs the depths of personal experience, connecting the past of Mediterranean culture with the present of his own artistic experience, and, thus, the timeless and the universal with the transitory moment.

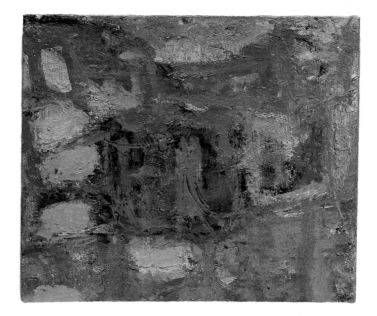

Cy Twombly, *Ritual*, 1949
Öl auf Leinwand, 50.8 x 61 cm
Oil on canvas, 20 x 24 inches

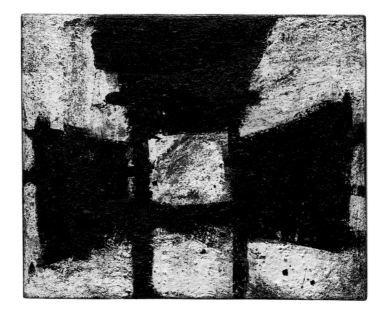

Cy Twombly, *Zyxig*, 1951
Ölfarbe und Erde auf Leinwand, 41 x 51 cm
Oil paint and earth on canvas
16 ⅛ x 20 ⅛ inches

"Was mich betrifft, so ist die Vergangenheit die
Quelle (denn alle Kunst ist in ihrem Wesens-
kern zeitgenössisch). Mich ziehen die primitiven,
die rituellen und als Fetisch dienenden Elemente
an, die symmetrische plastische Ordnung (die
insbesondere sowohl primitiven als auch klassi-
schen Konzepten zugrunde liegt und so beide
miteinander in Beziehung setzt)."

<div align="right">Cy Twombly, 1952</div>

"For myself the past is the source (for all art
is vitally contemporary). I'm drawn to the
primitive, the ritual and fetish elements, to
symmetrical plastic order (peculiarly basic to
both primitive and classic concepts, so
relating the two)." *Cy Twombly, 1952*

Cy Twombly, *Solon I*, 1952
Ölhaltige Kunstharzfarbe und Erde
auf Leinwand, 101.5 x 132.7 cm
Oil based house paint and earth
on canvas, 40 x 52 ¼ inches

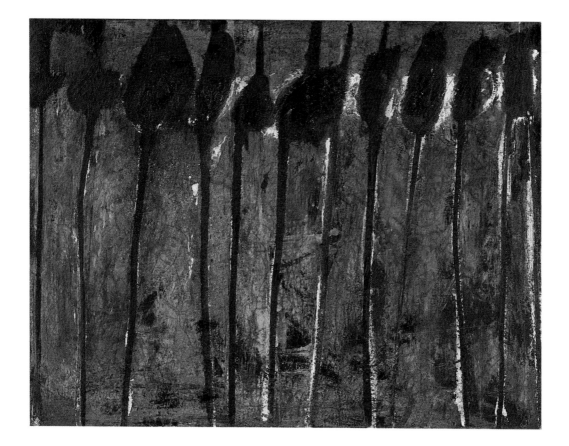

"Jede Linie ist also die tatsächliche Erfahrung
mit der ihr angeborenen Geschichte. Sie
illustriert nicht, sie ist die Empfindung ihrer
eigenen Verwirklichung." Cy Twombly, 1957

"Every line is therefore the actual experience
of its innate history. It does not illustrate; it
is the sensation of its own realization."

Cy Twombly, 1957

Cy Twombly, *The Geeks*, 1955
Ölhaltige Kunstharzfarbe, Pastellkreide und
Farbstift auf Leinwand, 108 x 127 cm
Oil based house paint, pastel, and colored
pencil on canvas, 42 ½ x 50 inches

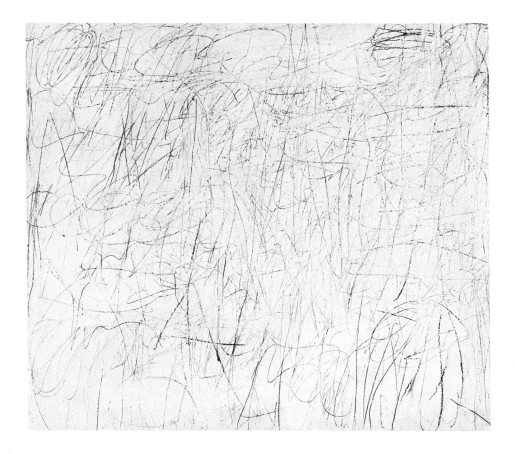

"Die Bildsprache ist eher die privater und los-
gelöster Befriedigungen als die einer abstrakten
Totalität visueller Wahrnehmung."
<div align="right">Cy Twombly</div>

*"The imagery is one of the private or sepa-
rate indulgencies rather than an abstract
totality of visual perception."*
<div align="right">*Cy Twombly*</div>

Cy Twombly, *Untitled (Roma)*, 1959
Öl, Wachskreide, Farbstift und
Bleistift auf Leinwand, 166 x 200 cm
Oil paint, wax crayon, colored pencil, and
lead pencil on canvas, 65 3/8 x 78 3/4 inches

"Das Problem liegt also in dem vollständigen
Ausdruck der eigenen Persönlichkeit mittels
jeder verfügbaren Fähigkeit."

Cy Twombly, 1956

*"The problem then lies in the complete ex-
pression of one's own personality through
every faculty available."*

Cy Twombly, 1956

Cy Twombly, *Ferragosto I (Roma)*, 1961
Öl, Wachskreide und Bleistift
auf Leinwand, 166 x 200 cm
Oil paint, wax crayon, and lead pencil
on canvas, 65 3/8 x 78 3/4 inches

Brice Marden

Peter Fischer

Auch wenn Mardens Werk Mitte der 80er Jahre einen abrupten Paradigmawechsel zu erfahren scheint – die Ablösung der Fläche durch die Linie, der Opazität durch die Transparenz – bleibt ihm eine Konstanz eigen. Es ist die Überzeugung des Künstlers, dass seine Werke einen kreativen Prozess dokumentieren, der eigentlich nie als abgeschlossen betrachtet werden kann. In einer extrem langsamen Arbeitsweise legt Marden immer neue Schichten auf seine Gemälde, immer wieder übermalt er, setzt Linien neu. Es ist die unstillbare Sehnsucht nach dem perfekten Bild, die ihn antreibt und auch aufreibt.

Mardens monochrome Wachstafeln sind trotz Parallelen nicht der Minimal Art zuzurechnen. Bezugspunkt und Vorbild ist vielmehr Cézanne, der die Farbe vom abgebildeten Gegenstand loslöste und ihr ein Eigenleben, eine autonome Qualität verlieh. Jasper Johns' Enkaustiktechnik (Öl-Wachsgemisch) eröffnete Marden ein Verfahren, das ihm erlaubte, den Cézanne'schen Anspruch einzulösen. Damit schuf er rechteckige, monochrome Tafeln, die bislang nicht gesehene Farben materialisierten, und in deren Kombinierung er akkordgleich visuelle Klangwelten komponierte.

Although Marden's work seems to undergo an abrupt paradigmatic shift in the mideighties—with line superseding surface and transparency replacing opacity—one constant factor remains: the artist's conviction that his works document a creative process that can never really be regarded as finished. In an extremely slow working process, Marden adds layer after layer to his painting, constantly overpainting and redrawing lines. He is both driven and chafed by the unappeasable yearning for the perfect picture.

Despite some parallels, Marden's monochrome wax paintings are not to be categorized as minimal art. Instead, their model and point of reference is Cézanne, who detached color from the objects he was depicting and gave it a life of its own, an autonomous quality. Marden saw that the technique of encaustic painting (a mixture of oil and wax) used by Jasper Johns allowed him to comply with Cézanne's requirements. He used it to create rectangular, monochrome paintings giving material expression to hitherto unseen colors, and by combining them he composed tonal worlds resembling chords in visual form.

Ende der 70er Jahre hatte Marden diese Technik perfektioniert, und in seinem zeichnerischen Werk begann sich schon länger ein Richtungswechsel abzuzeichnen, der sich ab 1985 auch in seinem malerischen Schaffen manifestieren sollte: Marden öffnete sich den Dimensionen von Raum und Zeit. Mindestens zwei Impulse waren ausschlaggebend: Für die Entwürfe der Glasfenster am Basler Münster setzte er sich ab 1978 mit dem Phänomen der Transparenz auseinander, und 1984 begann sein Interesse an japanischer und chinesischer Kalligraphie. Beide Techniken, die Glasmalerei wie die Kalligraphie, machen plötzlich sichtbar, was die Wachsschichten seiner bisherigen Gemälde unwiederbringlich versiegelt haben: Den Prozess ihrer Entstehung. Waren letztere eine undurchdringliche Haut, die nur ihre eigene Oberfläche zeigt, erlauben die neuen Techniken einen Einblick ins Innenleben der Bilder. Nun ist es Pollock, der Marden mit seinem nachvollziehbaren Bildaufbau neue Wege weist. Das sichtbare Wechselspiel zwischen den Schichten lässt die Gemälde atmen. Es ist nur folgerichtig, dass Mardens Werke der 90er Jahre dynamischer werden – oft gleichsam bevölkert von tanzenden Figuren – und Einblick gewähren in den nie vollendeten Prozess des Lebens.

By the end of the seventies Marden had perfected this technique, and a change of direction had already begun to show in his graphic work. This change of direction was also to be evident in his paintings after 1985: Marden was opening up to the dimensions of time and space. At least two factors were of crucial significance: from 1978 onward he was concerned with the phenomenon of transparency in his designs for the windows of Basle Cathedral, while his interest in Japanese and Chinese calligraphy dated from 1984. Both techniques— glass painting and calligraphy—suddenly revealed what the layers of wax paint had irrevocably sealed up in his earlier paintings: the process of their creation. While those layers had been an impenetrable skin showing only its own surface, his new techniques revealed an internal life. It was Pollock, with the readily comprehensible structure of his pictures, who now pointed the new way ahead for Marden. The visible interplay of the layers allows Marden's paintings to breathe, and logically enough his pictures of the nineties are more dynamic than the earlier works, often appearing to be populated by dancing figures. They provide an insight into the never-ending process of life itself.

"Das Rechteck, die Fläche, die Struktur, das
Bild sind nichts als der Resonanzboden für den
Geist."

Brice Marden, 1971-72

*"The rectangle, the plane, the structure, the
picture are but sounding boards for a spirit."*

Brice Marden, 1971-72

Brice Marden, *Untitled*, 1964-68
Graphit auf Papier, 67.5 x 101.5 cm
Graphite on paper, 26 ½ x 40 inches

Brice Marden, *Starter*, 1971
Öl und Wachs auf Leinwand, drei Teile
92 x 244 cm insgesamt
Oil and wax on canvas, three panels
36 x 96 inches overall

Brice Marden, *For Hera*, 1977
Öl und Wachs auf Leinwand,
drei Teile, 213 x 305 cm insgesamt
Oil and wax on canvas, three panels
84 x 120 inches overall

"Ich male Bilder, die aus einem, zwei oder drei Teilen bestehen. Ich arbeite von einem Teil zum anderen. Ich werde am einen malen, bis ich bei einer Farbe angelangt bin, die diese Fläche hält. Ich gehe dann zum nächsten Teil und male, bis etwas diese Fläche hält und auf interessante Weise mit den anderen Teilen in Beziehung tritt. Ich arbeite am dritten Teil und suche nach einem Farbwert, der alle Flächen innerhalb eines Bildganzen zusammenhält und diesem eine ästhetische Bedeutung verleiht. Dieser Prozess ist nicht so einfach, wie es hier scheint. Die einzelnen Teile müssen mehrfach übermalt werden, was keinen bestimmten Regeln folgt. Die Idee von einem Bild kann sich ziemlich schnell und drastisch ändern oder sich sehr langsam entwickeln. Ich will mit dem Gemälde in einen Dialog treten: Es arbeitet an mir, und ich arbeite an ihm."

Brice Marden, 1973

"I paint paintings made up of one, two, or three panels. I work from panel to panel. I will paint on one until I arrive at a colour that holds that plane. I move to another panel and paint until something is holding that plane that also interestingly relates to the other panels. I work the third, searching for a colour value that pulls the planes together into a plane that has aesthetic meaning. This process is not as simple as explained. There is much repainting of panels which follows no given order. The ideas of a painting can change quite fast and drastically or they can evolve very slowly. I want to have a dialogue with the painting: it works on me and I work on it."

Brice Marden, 1973

Brice Marden
Elements I, 1981-82
Öl auf Leinwand, vier Teile
219 x 129.5 cm insgesamt
Oil on canvas, four panels
86 ¼ x 51 inches overall

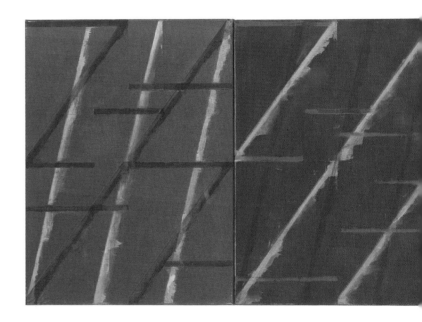

Brice Marden
Second Window Painting, 1983
Öl auf Leinen, fünf Teile,
61 x 228.6 cm insgesamt
Oil on linen, five panels
24 x 90 inches overall

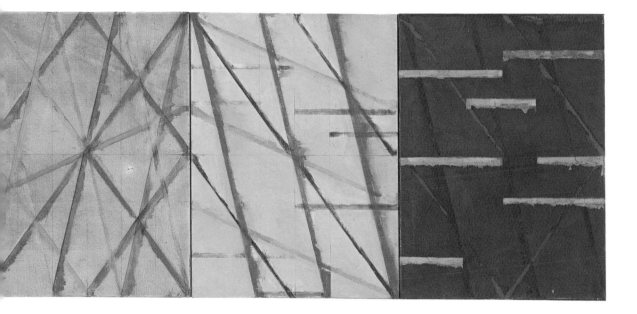

"Ich weiss, das ist heikel, aber ich möchte Malerei als spirituelle Angelegenheit definieren. Welche Inhalte oder Strukturen ich beim Malen auch immer einbringe (und sie gebrauche, sie umarbeite, mich auf sie als Faktoren verlasse), Malerei hat immer damit zu tun, dass man sich irgendetwas annähert, das man nicht kennt oder nicht versteht. Der Weg, der mich dahin führt, ist ein visueller." Brice Marden, 1991

"I know it's tricky ground, but I like to define painting in spiritual terms. Whatever subject matter or structure I bring to the painting—and use and work through and rely on as factors—for me painting is always about getting toward something I don't know about or understand. The way I get there is visual." Brice Marden, 1991

Brice Marden
Untitled #1, 1986
Öl auf Leinen, 183 x 147 cm
Oil on linen, 72 x 58 inches

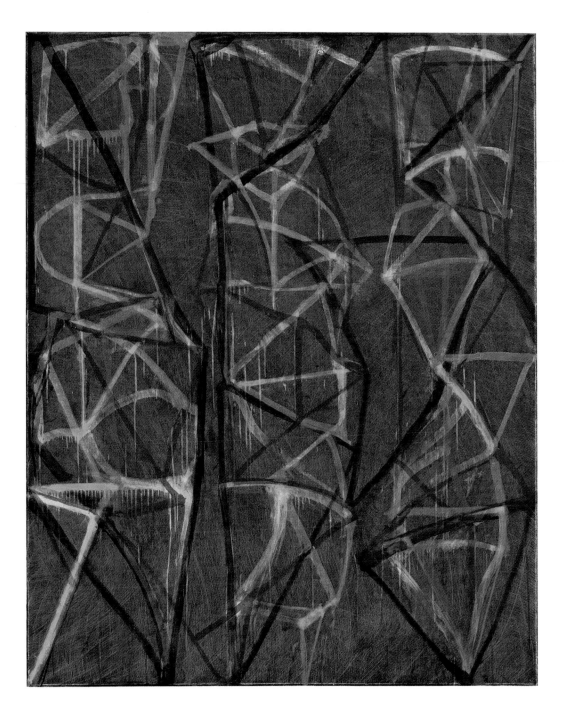

Ross Bleckner

Peter Fischer

In den 70er Jahren eine Karriere als Maler zu beginnen setzte nicht nur Selbstvertrauen voraus, sondern auch eine Unbeschwertheit gegenüber dem modernen Avantgardedenken. Neue Ausdrucksformen wie die Installation und die Performance beherrschen die Kunstszene, Malerei findet fast nur noch innerhalb eines strengen minimalistischen Konzepts statt. In diesem Umfeld trifft am California Institute of the Arts eine Gruppe junger Künstler zusammen, die mit ihrer Malerei die Kunst der 80er Jahre mitprägen werden: Unter ihnen Ross Bleckner, Eric Fischl und David Salle. Der Wiederbelebung der Malerei kamen die Konzepte der Postmoderne und des Poststrukturalismus zugute, die sich gegen das lineare, positivistische Gedankengut der Moderne wendeten.

Bleckner macht sich die neuartige Verfügbarkeit der Kunstgeschichte zunutzen. Dies beginnt bei einer stupenden handwerklichen Technik, die er bezüglich seiner Lichtführung in altmeisterlicher Manier anwendet. Er bedient sich aber auch gezielt des Vokabulars der Kunstgeschichte, indem er die fiktiven Räume seiner Gemälde mit Objekten von hohem Symbolgehalt und emotionalem Potential inszeniert. So dispa-

To embark on a career as a painter in the seventies presupposed not just self-confidence but an insouciant attitude to modern avantgarde thinking. New forms of expression such as installations and performance art dominated the artistic world of the time, and painting was practiced almost exclusively within a strict minimalist concept. It was in this context that a group of young artists whose painting would be influential in shaping the art of the eighties came together at the California Institute of the Arts: they included Ross Bleckner, Eric Fischl, and David Salle. The revival of painting benefited by the concepts of postmodernism and poststructuralism, which turned against the linear and positivist ideas of modernism.

Bleckner makes good use of the new availability of the historical artistic tradition, beginning with the great mastery of craftsmanlike techniques which he employs in his treatment of light, in a manner reminiscent of the Old Masters. However, he also deliberately uses the vocabulary of the history of art by filling the fictitious spaces of his paintings with objects of high sym-

rat Bleckners Werk auf den ersten Blick erscheint, den Künstler beschäftigt doch immer derselbe klassische Themenkomplex: Die Frage nach dem Anfang und dem Ende, nach Leben und Tod, Licht und Dunkel, damit verbunden das Verlangen nach Ordnung und die Sehnsucht nach Schönheit.

Die Streifenbilder, die in Bleckners Werk eine formale Konstante bilden, sind eine Metapher für unser Gefangensein innerhalb eines grösseren Zusammenhangs, aber auch – als Zitat der Op-Art, einer folgenlosen Kunstströmung der 60er Jahre – ein kritischer Kommentar zum Unvermögen der Moderne, für unsere Zeit gültige Antworten hervorzubringen. Das aktuelle Thema ist die universale Bedrohung durch Aufrüstung, neue Technologien, rücksichtslosen Umgang mit den natürlichen Ressourcen und – von Bleckner hautnah miterlebt – Aids. Für diese Probleme gibt es keine einfachen Antworten, sondern sie müssen erarbeitet und erlitten werden, wovon Bleckners Gemälde Zeugnis ablegen: Häuten gleich tragen sie Spuren dieses Erkenntnisprozesses. Oft überspannen sie die nur schwer erträgliche Trauerarbeit, bis sie ins Kitschige kippen. Sie suchen Gesetzmässigkeiten zu erfassen, im Mikro- wie im Makrokosmos.

bolic content and emotional potential. Disparate as Bleckner's work may seem at first glance, the artist is always concerned with the same classic complex of themes: questions of the beginning and the end, life and death, light and darkness, and bound up with them the desire for order and a yearning for beauty.

The paintings of stripes, a constant formal factor in Bleckner's work, are a metaphor for our imprisonment within a wider context, but are also—regarded as a quotation from Op Art, an artistic current of the sixties that led nowhere—a critical commentary on the inability of modernism to produce any answers relevant to our own times. The artist's current theme is the universal threat presented by the arm race, new technologies, the thoughtless squandering of natural resources, and AIDS—the last-named a subject very close to Bleckner's own experience. There are no simple answers to these problems which, as Bleckner's paintings eloquently testify, must be worked through and suffered: like skin, they bear the marks of this process of recognition. Often, they span the barely tolerable process of grieving until they tip over into kitsch. They seek to grasp the laws inherent in the microcosm and the macrocosm alike.

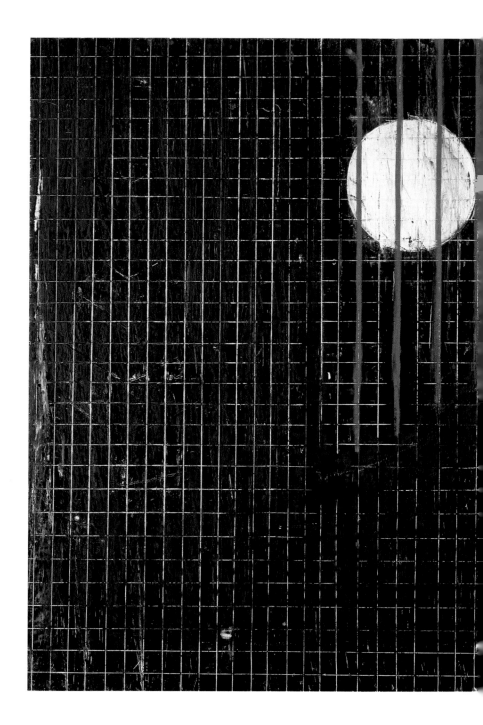

Ross Bleckner, *Two Artists*, 1981
Öl auf Leinwand, zwei Teile
203.5 x 305.5 cm insgesamt
Oil on canvas, two panels
80 x 120 inches overall

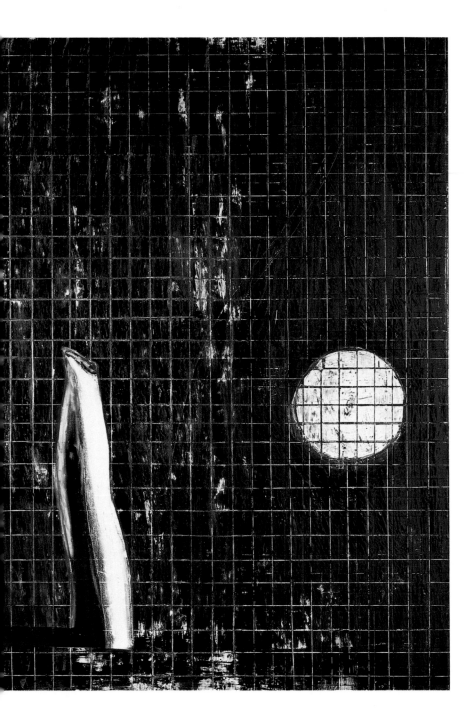

Ross Bleckner, *Untitled*, 1981
Öl und Wachs auf Leinwand, 244 x 548.6 cm
Oil and wax on canvas, 96 x 216 inches

"Ich habe immer noch das Gefühl, man könne mit bestimmten Bildern über Dinge sprechen. In meinem Fall interessiere ich mich für das besondere Licht, das versucht, die Idee des Schizophrenen zu thematisieren, die nach meinem Dafürhalten nicht ganz verstanden wird, obwohl sie heute relevanter ist denn je."

Ross Bleckner, 1988

"I still feel that you can speak about things through kinds of images. Or in my case, the kind of light I'm interested in tries to bring into its discourse the idea of schizophrenia, which I don't believe is fully understood, nor was it ever as relevant as it is today."

Ross Bleckner, 1988

Ross Bleckner, *Weather*, 1983
Öl auf Leinen, 229 x 183 cm
Oil on linen, 90 x 72 inches

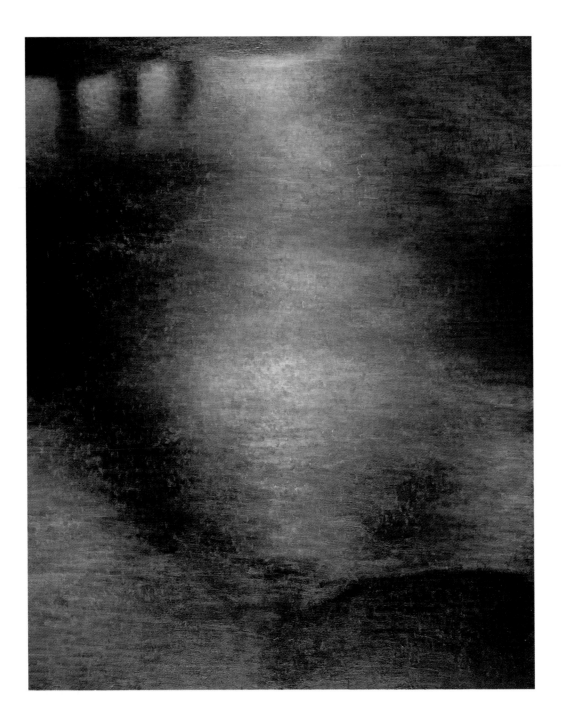

"Mir gefällt es, wenn ein Bild etwas Theaterhaftes hat, ein Spiel zwischen Stimmung und Auseinandersetzung. Was mir vorschwebt, ist eine beständige Expansion und Kontraktion innerhalb einer Gruppe von Bildern. Auf diese Weise kann ich mich mit den Begriffen von Enttäuschung und Zusammenbruch beschäftigen. Diese Vorstellung von Expansion und Kontraktion ist eine sehr organische Bewegung. Wir denken nicht nur so, wir leben und sterben auch so."

Ross Bleckner, 1988

"I like a painting to possess a sense of theater, a play between mood and confrontation. I want a constant expansion and contraction of sets of images. That way I can deal with the idea of disillusionment and collapse. That sense of expansion and contraction is a very organic movement. It's not just the way we think, it's the way we live and die."

Ross Bleckner, 1988

Ross Bleckner
Hospital Room, 1985
Öl auf Leinen, 122 x 101.5 cm
Oil on linen, 48 x 40 inches

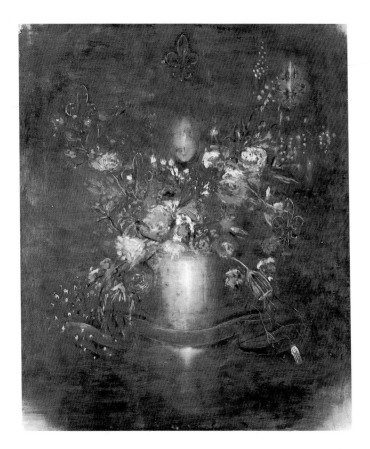

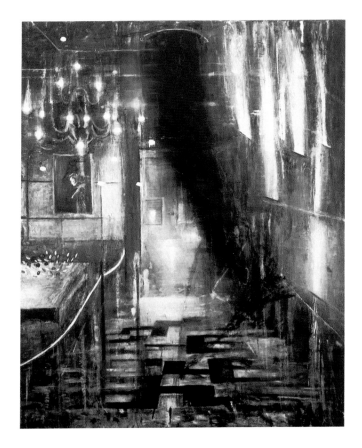

Ross Bleckner
Interior (With White Dots), 1985
Öl auf Leinwand, 122 x 101.5 cm
Oil on canvas, 48 x 40 inches

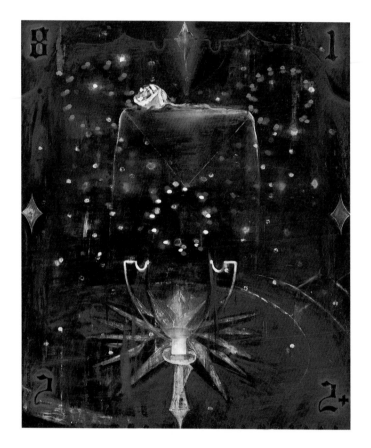

Ross Bleckner
8,122+ As of January 1986, 1986
Öl auf Leinen, 122 x 101.5 cm
Oil on linen, 48 x 40 inches

"Durch sie [die Streifenbilder] fand ich einen Weg, eine List, die Bilder zu machen, die ich wirklich machen wollte. Durch sie bin ich auf eine Arbeitsweise gekommen, die dieses beständig pulsierende, innere Glühen hat, das sich vorantreibt. [...] Ich möchte nicht, dass sie nur Streifenbilder sind. Sie sollen emblematisch sein."

Ross Bleckner, 1988

"They [the stripe paintings] brought me to a way of working that has this continuous, pulsating, inner glow that keeps pushing itself. [...] I don't want to make them simply stripe paintings. I want them to be emblematic."

Ross Bleckner, 1988

Ross Bleckner
Circle of Us, 1987
Öl auf Leinwand, 274 x 183 cm
Oil on canvas, 108 x 72 inches

"Ich schaffe die Stimmung meiner Bilder nicht, meine Lebensumstände tun das. Meine Bilder reflektieren die Angst und die Trauer meiner Stimmung. Ich erschaffe sie nicht, sie erschafft mich."

<div align="right">Ross Bleckner, 1993</div>

"I don't create the mood of my paintings, the conditions of my life do. My paintings reflect the anxiety and sadness of my mood. I don't create it, it creates me."

<div align="right">*Ross Bleckner, 1993*</div>

<div align="right">Ross Bleckner
Architecture of the Sky, 1989
Öl auf Leinwand, 269 x 234 cm
Oil on canvas, 106 x 92 inches</div>

Ross Bleckner
Overexpression, 1998
Öl auf Leinen, 213.5 x 183 cm
Oil on linen, 84 x 72 inches

Andy Warhol

Geboren / Born 1928 in Pittsburgh, Pennsylvania
Gestorben / Died 1987 in New York City

Auswahlbibliographie / Selected Bibliography:

Rainer Crone, *Andy Warhol*, Teufen: Niggli, 1970.
(English edition: New York: Praeger, 1970.)

Thomas Crow, "Saturday Disasters: Trace and
Reference in Early Warhol," in: Art in America,
vol. 75, May 1987, reprinted in: Thomas Crow,
Modern Art in the Common Culture, New Haven /
London: Yale University Press, 1996, pp. 49-65.

Parkett, no. 12, 1987. [Mit Beiträgen von / With
contributions by Stuart Morgan, Glenn O'Brien,
Remo Guidieri, Robert Becker]

David Bourdon, *Andy Warhol*, New York: Harry N.
Abrams, 1989. (Deutsche Ausgabe: Köln: DuMont,
1989.)

Kynaston McShine, *Andy Warhol: A Retrospective*,
New York: The Museum of Modern Art, 1989.
(Deutsche Ausgabe: Kynaston McShine, *Andy
Warhol: Retrospektive*, München: Prestel, 1989.)

Martin Schwander (ed.), *Andy Warhol:
Paintings 1960-1986*, Stuttgart: Hatje, 1995.

Rosalind Krauss, "Warhol's Abstract Spectacle," in:
Yve-Alain Bois (et al.), *Abstraction, Gesture, Ecriture:
Paintings from the Daros Collection*, Zurich / Berlin /
New York: Scalo, 1999, pp. 123-34.

Sigmar Polke

Geboren / Born 1941 in Oels / Schlesien
Lebt und arbeitet in Köln
Lives and works in Cologne

Auswahlbibliographie / Selected Bibliography:

John Caldwell (et al.), *Sigmar Polke*, San Francisco:
San Francisco Museum of Modern Art, 1990.

Parkett, no. 30, 1991. [Mit Beiträgen von / With
contributions by Bice Curiger, Thomas McEvilley,
Gary Garrels, Lazlo Glozer, Dave Hickey, Gabriele
Wix, G. Roger Denson]

Wim A. L. Beeren (et al.), *Sigmar Polke*, Amsterdam:
Stedelijk Museum, 1992.

Martin Hentschel, *Sigmar Polke: Laterna Magica*,
Frankfurt M. / Stuttgart: Portikus, 1995.

David Thistlewood (ed.), *Sigmar Polke: Back to
Postmodernity*, Liverpool: Liverpool University Press
and Tate Gallery Liverpool, 1996 (Tate Gallery
Liverpool Critical Forum Series, vol. 4).

Martin Hentschel (Hrsg.), *Sigmar Polke: Die drei
Lügen der Malerei*, Bonn: Kunst- und Ausstellungs-
halle der Bundesrepublik Deutschland, 1997.
(English edition: Martin Hentschel (ed.), *The Three
Lies of Painting*, Stuttgart: Cantz, 1997.)

Margit Rowell (et al.), *Sigmar Polke: Works on Paper
1963-1974*, New York: The Museum of Modern Art,
1999.

Gerhard Richter

Geboren / Born 1932 in Dresden
Lebt und arbeitet in Köln
Lives and works in Cologne

Auswahlbibliographie / Selected Bibliography:

Jürgen Harten (ed.), *Gerhard Richter: Bilder /
Paintings 1962-1985*, Köln: DuMont, 1986.

Benjamin Buchloh (et al.), *Gerhard Richter*, Bonn:
Kunst- und Ausstellungshalle der Bundesrepublik
Deutschland; Stuttgart: Cantz, 1993, 3 vols.

Parkett, no. 35, 1993. [Mit Beiträgen von / With
contributions by Jean-Pierre Criqui, Peter Gidal,
Birgit Pelzer, Gertrud Koch, Dave Hickey]

Gerhard Richter, *Text: Schriften und Interviews*, hrsg.
von Hans-Ulrich Obrist, Frankfurt M. / Leipzig: Insel
Verlag, 1993. (English edition: Gerhard Richter, *The
Daily Practice of Painting: Writings and Interviews
1962-1993*, ed. by Hans-Ulrich Obrist, Cambridge,
Mass.: MIT Press in association with the Anthony
d'Offay Gallery, London, 1995.)

Gerhard Richter, *Atlas der Fotos, Collagen und
Skizzen*, hrsg. von Helmut Friedel und Ulrich
Wilmes, Köln: Oktagon, 1997.

Gerhard Richter 1998, with essays by Martin
Hentschel and Helmut Friedel, London: Anthony
d'Offay Gallery, 1998.

Cy Twombly

Geboren / Born 1928 in Lexington, Virginia
Lebt und arbeitet in Lexington, Rom und Gaeta
Lives and works in Lexington, Rome and Gaeta

Auswahlbibliographie / Selected Bibliography:

Robert Pincus-Witten, "Learning to Write" (1968),
reprinted in: Robert Pincus-Witten, *Eye to Eye:
Twenty Years of Art Criticism*, Ann Arbor, Mich.:
U.M.I. Research Press, 1984, pp. 87 ff.

Roland Barthes, "Sagesse de l'Art" / "The Wisdom
of Art," in: David Whitney (ed.), *Cy Twombly:
Paintings and Drawings 1954-1977*, New York:
Whitney Museum of American Art, 1979, pp. 9-22.

Katharina Schmidt, *Cy Twombly*, Baden-Baden:
Staatliche Kunsthalle, 1984.

Heiner Bastian, *Cy Twombly: Catalogue Raisonné
of the Paintings*, 4 vols., München: Schirmer-Mosel,
1992-95.

Kirk Varnedoe, *Cy Twombly: A Retrospective*, New
York: The Museum of Modern Art, 1994. (Deutsche
Ausgabe: Kirk Varnedoe, *Cy Twombly: Eine Retro-
spektive*, München / Paris / London: Schirmer-Mosel,
1994.)

Yve-Alain Bois, "'Der liebe Gott steckt im Detail':
Reading Twombly," in: Yve-Alain Bois (et al.),
*Abstraction, Gesture, Ecriture: Paintings from the
Daros Collection*, Zurich / Berlin / New York: Scalo,
1999, pp. 61-83.

Brice Marden

Geboren / Born 1938 in Bronxville, New York
Lebt und arbeitet in New York, Pennsylvania
und Griechenland
Lives and works in New York, Pennsylvania
and Greece

Auswahlbibliographie / Selected Bibliography:

Parkett, no. 7, 1986. [Mit Beiträgen von / With
contributions by Carter Ratcliff, Lisa Liebmann, Franz
Meyer, Francesco Pellizzi]

Klaus Kertess, *Brice Marden: Paintings and
Drawings*, New York: Harry N. Abrams, 1992.

Brenda Richardson, *Brice Marden: Cold Mountain*,
Houston: Houston Fine Art Press, 1992.

Dieter Schwarz / Michael Semff (eds.), *Brice Marden:
Work Books 1964-1995*, München: Staatliche
Graphische Sammlung; Winterthur: Kunstmuseum;
Cambridge, Mass.: Harvard University Art
Museums, 1997.

Brenda Richardson, "Brice Marden: Lifelines," in:
Yve-Alain Bois (et al.), *Abstraction, Gesture, Ecriture:
Paintings from the Daros Collection*,
Zurich / Berlin / New York: Scalo, 1999, pp. 85-103.

Charles Wylie, *Brice Marden: Works of the 1990s:
Paintings, Drawings, and Prints*, Dallas: Dallas
Museum of Art, in association with D.A.P.,
New York, 1999.

Ross Bleckner

Geboren / Born 1949 in New York
Lebt und arbeitet in New York
Lives and works in New York

Auswahlbibliographie / Selected Bibliography:

Peter Halley, "Ross Bleckner: Painting at the End
of History," in: *Arts Magazine*, vol. 56, no. 9, May
1982, reprinted in: Peter Halley, *Collected Essays
1981-1987*, Zürich: Bruno Bischofberger Gallery;
New York: Sonnabend Gallery, 1988, pp. 47-60.

Bernhard Bürgi, *Ross Bleckner*, Zürich: Kunsthalle;
Stockholm: Moderna Museet, 1990.

Parkett, no. 38, 1993. [Mit Beiträgen von / With
contributions by Edmund White, Simon Watney,
Jose Luis Brea, David Seidner]

David Carrier, "Critical Camp," in: *Artforum*, vol. 33,
February 1995, pp. 69-74, 105.

Lisa Dennison (ed.), *Ross Bleckner*, New York:
Solomon R. Guggenheim Museum, 1995.

Neville Wakefield, "Easy Virtue," in: *Artforum*,
vol. 33, February 1995, pp. 69-74, 105, 110.

Wilfried Dickhoff, *Ross Bleckner*, Wien: Bawag
Foundation, 1997.

Nachweis der Künstlerzitate / Reference of artists' quotations

p. 52 "New talent U.S.A.," in: *Art in America*,
vol. 50, no.1 (1960), p. 42, abgedruckt in: Kynaston
McShine (Hrsg.), *Andy Warhol: Retrospektive*,
München: Prestel, 1989, S. 450 / reprinted in:
Kynaston McShine (ed.), *Andy Warhol: A Retro-
spective*, New York: Museum of Modern Art,
1989, p. 458.

p. 56 Andy Warhol / Pat Hackett, *POPism: The
Warhol '60s*, London: Pimlico, 1996, p. 50.

p. 60 Kynaston McShine, op.cit., S. 451 / p. 459.

p. 64 Andy Warhol / Pat Hackett, op.cit., p. 3.

p. 76 "Ein Bild ist an sich schon eine Gemeinheit:
Bice Curiger im Gespräch mit Sigmar Polke /
Poison is Effective; Painting is Not: Bice Curiger in
conversation with Sigmar Polke," in: *Parkett*,
No. 26, 1990, S. 10-11 / p. 21.

p. 82 Ibid., S. 13 / p. 24.

p. 86 Gerhard Richter, *Text: Schriften und Interviews*,
hrsg. von Hans-Ulrich Obrist, Frankfurt M. / Leipzig:
Insel Verlag, 1993, S. 31 / Gerhard Richter, *The
Daily Practice of Painting: Writings and Interviews
1962-1993*, edited by Hans-Ulrich Obrist, Cambridge,
Mass.: MIT Press in association with the Anthony
d'Offay Gallery, London,1995, p. 37.

p. 90 Ibid., S. 63 / p. 68.

p. 92 Ibid., S. 155 / p. 166.

p. 98 Kirk Varnedoe, *Cy Twombly: Eine Retrospektive*,
München / Paris / London: Schirmer-Mosel, 1994,

Anm. 48, S. 62 / Kirk Varnedoe, *Cy Twombly:
A Retrospective*, New York: The Museum of
Modern Art, 1994, note 48, p. 56.

p. 100 Esperienza moderna, no. 2, 1957; zitiert in:
Bernhard Kerber, *Amerikanische Kunst seit 1945:
Ihre theoretischen Grundlagen*, Stuttgart: Reclam,
1971, S. 92.

p. 102 Kirk Varnedoe, op.cit., S. 30 / p. 28.

p. 104 Kirk Varnedoe, op.cit., Anm. 99,
S. 67 / note 99, p. 61.

p. 108 *Brice Marden: Paintings, Drawings and
Prints 1975-80*, London: Whitechapel Art Gallery,
1981, p. 55.

p. 114 Ibid., p. 55.

p. 118 Brenda Richardson, "Brice Marden: Lifelines," in:
Yve-Alain Bois (et al.), *Abstraction, Gesture,
Ecriture: Paintings from the Daros Collection*, Zurich /
Berlin / New York: Scalo, 1999, p. 101.

p. 126 Dan Cameron, *NY Art Now: The Saatchi
Collection*, London: Saatchi Collection, c. 1988, p. 46.

p. 128 Trevor Fairbrother / David Joselit / Elisabeth
Sussman, *The Binational: Amerikanische Kunst der
späten 80er Jahre / American Art of the late 80s*, Bo-
ston, Mass.: The Institute of Contemporary Art
and Museum of Fine Arts; Köln: DuMont, 1988,
S. 60 / p. 60.

p. 132 Ibid., S. 59 / pp. 58-59.

p. 134 *Parkett*, no. 38, 1993, S. 72 / p. 70.